TIME
ZONES

TIME ZONES

Recent Film
and Video

First published 2004 by order of the Tate Trustees
by Tate Publishing, a division of Tate Enterprises Ltd,
Millbank, London SW1P 4RG, www.tate.org.uk

On the occasion of the exhibition at Tate Modern, London
6 October 2004 – 2 January 2005

Exhibition sponsored by

Essay by Sylviane Agacinski © 2004 Columbia University Press.
Reprinted with permission of the publisher

British Library Cataloguing-in-Publication Data
A catalogue record for this book is available from the British Library

ISBN 1-85437-549-0

Distributed in the USA and Canada by Harry N. Abrams, Inc., New York

Library of Congress Cataloging-in-Publication Data
Library of Congress Control Number: 2004103233

Designed by James Goggin and Sara De Bondt / Practise
Printed in England by T.J. International Ltd, Cornwall

Front cover: Details of
Fiona Tan, *Saint Sebastian* 2001; Jeroen de Rijke and Willem de Rooij, *Untitled* 2001;
Fiona Tan, *Rain* 2001; Anri Sala, *Blindfold* 2002;
Yael Bartana, *Kings of the Hill* 2003; Wolfgang Staehle, *Comburg* 2001;
Fikret Atay, *Rebels of the Dance* 2002; Francis Alÿs, *Zocalo. May 20, 1999* 1999;
Yang Fudong, *Liu Lan* 2003

Back cover: Details of
Yael Bartana, *Kings of the Hill* 2003; Yang Fudong, *Liu Lan* 2003;
Anri Sala, *Blindfold* 2002; Bojan Sarcevic, *Untitled (Bangkok)* 2002;
Fiona Tan, *Rain* 2001

Contents

Sponsor's Foreword

Varilux is proud to sponsor *Time Zones: Recent Film and Video*, the first major exhibition at Tate Modern devoted exclusively to the moving image.

As Varilux invented varifocal lenses and are at the leading edge of varifocal technology, we feel it's particularly fitting to be supporting an exhibition so intrinsically linked to vision.

The speed of the present day is such that the detail and some of the wonder of living is often lost. This exhibition will examine the implications of an increasing number of contemporary works that attempt to slow or 'layer' time. In a deliberate attempt to defy common practice, the artists reveal the richness of the overlooked and in doing so, emphasise the difference of place, space and time.

At Varilux, we also have a passion for ensuring we miss none of life's details so we hope you enjoy the exhibition.

Michel Crombé
Managing Director, Varilux

Director's Foreword

Perhaps the most radical effect of the introduction of new technologies is the manner in which our perception of time is both altered and made apparent in material form. Time-based media can simultaneously reflect new visual, philosophical, and poetical approaches to time, and play an integral role in the process of changing our perception and understanding of the spatial and temporal. *Time Zones* proposes a reconsideration of the representation and role of time in recent video and film, reflecting the continued spatial and temporal differences that co-exist globally. The ten artists included are represented by works that reassert the importance of duration and observation for artist and viewer alike.

This exhibition, which constitutes Tate Modern's first to concentrate on moving image, was conceived and developed by Jessica Morgan and Gregor Muir. Their insightful attention informs both the selection of works and the accompanying catalogue. The two curators' essays elucidate the theme of *Time Zones* while the contributions of Sylviane Agacinski, Professor at Ecole des Hautes Etudes, Paris; Peter Osborne, Professor of Modern European Philosophy and Director, Centre for Research in Modern European Philosophy, Middlesex University; and Irit Rogoff, Professor of Cultural Studies at Goldsmiths College, provide a theoretical basis for the exploration of current visual approaches to time and space in the exhibition. We are very grateful for their participation in this project. The catalogue has been intelligently designed by James Goggin and Sara De Bondt of Practise, and the project editor, Mary Richards, and production manager, Emma Woodiwiss, have

overseen the production with care and unfailing attention. The assistance of Maeve Polkinhorn for both the exhibition and the catalogue has proved invaluable. We also thank Anna Nesbit whose technical assistance was essential for the smooth realisation of this complex installation. Anna Mustonen helped to research images and background information.

We would like to express our sincere thanks to Varilux varifocals for their generous sponsorship of this exhibition, which has enabled many of the works to be shown in the United Kingdom for the first time. We are also very grateful for the support of the Mondriaan Foundation, Amsterdam.

Many individuals and galleries have helped in the loan of works and the development of the catalogue; we would like to thank the following for their support: Bernadette Schwering, Katharina Forero and Daniel Buchholz of Galerie Daniel Buchholz; Chantal Crousel, Nicolas and Karen Tanguy of Galerie Chantal Crousel; Annet Gelink and Floor Wullems of Annet Gelink Gallery; Jane Hamlyn, Dale McFarland and Kirsten Dunne of Frith Street Gallery; Lisa Rosendahl and Justyna Niewiara of Lisson Gallery; Magdalena Sawon of Postmasters Gallery; Laura Zhou and Helen Zhu of ShanghART Gallery; Joern Boetnagel and Yvonne Quirmbach of BQ Galerie; Curt Marcus, Marc Payot, and Sabine Sarwa of Galerie Hauser & Wirth.

Each artist has contributed significantly to the realisation of this exhibition. We thank them all for their patient and thoughtful insights into the planning and execution of the installation and catalogue. It is a pleasure to present their timely and complex visions to our audience.

Vicente Todolí
Director, Tate Modern

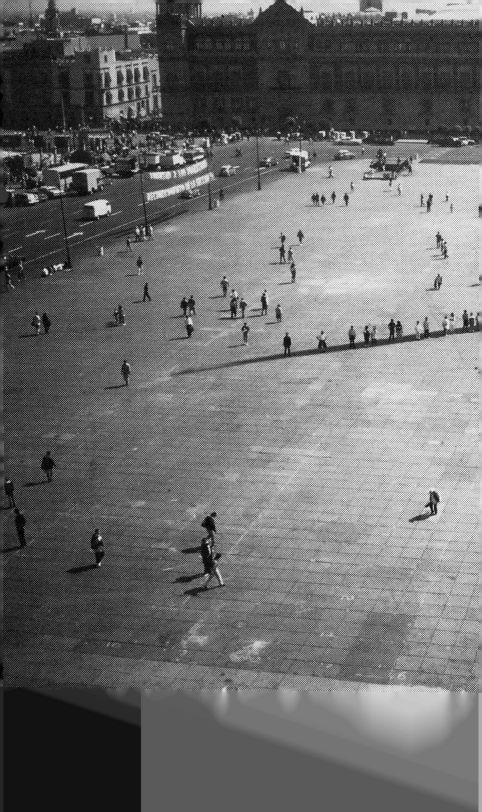

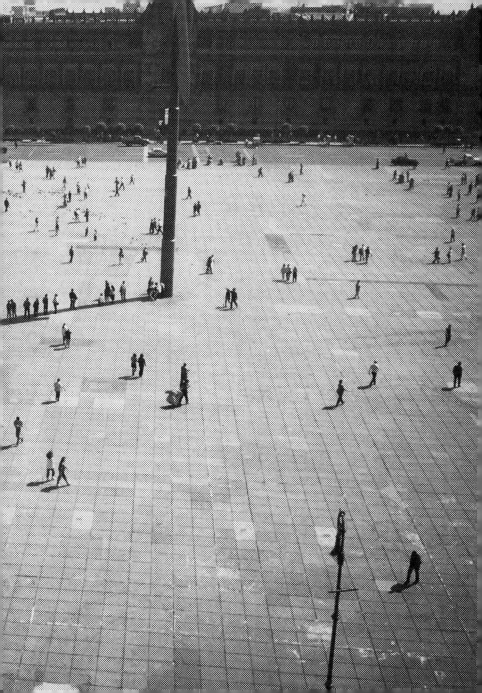

Jessica Morgan

TIME
AFTER
TIME

Other Time

Viewed from an elevated position, the vast expanse of the plaza is dominated by a grid of paving stones whose rigid structure is interrupted by the random movement of pedestrians and a massive undulating shadow cast by a huge flag that stands in the centre of the square. This near-constant movement draws attention to a peculiar stillness that is present in the column of static shade thrown by the flagpole. Somewhat obscured, a row of figures vertically articulates this darkness, escaping the otherwise relentless light that falls on the exposed piazza. The strangeness of this linear pause is enhanced by the fact that most of the people stand alone, facing not one another but out onto the plaza as if waiting for an opportune moment to continue their passage across the square, or watching the other pedestrians from a privileged position of murky anonymity. The narrow width of the shadow suggests that those pedestrians within it are intensely aware of the movement of the earth as the shade almost perceptibly moves from under their feet. Perhaps it is this literal passage of time, following the sundial-like turn of the shadow/clock hand, which appeals to those standing in the shade — who enjoy a wilful avoidance of the pressure to 'do' anything but follow the earth's rotation.

The plaza itself is immediately familiar to many, and identified in the title of this video by Francis Alÿs as Zocalo, Mexico City (pp.12–13, 17). Originally the site of the most significant Aztec temples, and subsequently replaced by colonial structures including the still-dominant Cathedral, the square is now home to the National Palace, City Hall and a Holiday Inn. The paved surface was the work of the revolutionary government and its size is second only to Moscow's Red Square, both sites having been built for the purpose of dramatic political displays. Zocalo has continued to be the favoured destination for demonstrations, and even in the absence of such organised activity, the staging of the plaza is such that the chance movements of the flag, the pedestrians and the stillness of those lining the shadow, appear to be choreographed by some unseen force. This twelve hour 'performance' captured by Alÿs is of the everyday, but the nature of the quotidian life on show is particular to its location: its history; climate; geography; and above all, economics. To observe from this film that time is a social construct may be nothing new, and to reflect that in Mexico City people pause to stand in the shade perhaps serves only to bolster clichés of north/south. But Alÿs's presentation of *Zocalo* suggests more than the discovery of a sculpture of found movement. The shadowy figures have intuitively created place out of something as ephemeral as the absence of light, rather than the substance of architecture. This occupation, however fragmented, suggests a kind of affirmation, recalling the public purpose of the site.

The duration of Alÿs's work begs comparison to that staple reference for all film or video art that focuses a camera on an iconic location for a day: Andy Warhol's *Empire* (1964). Boris Groys has observed that, among its many qualities, Warhol's film inverts the relationship between artist and viewer. Groys states: 'It used to be that the artist had to invest a great deal of time in creating work, which the viewer was then able to see at one go, so time was apportioned in the viewer's favour but to the artist's disadvantage … But *Empire* took exactly the same length of time to make as it does to watch it.' [1] As with *Empire*, it is unnecessary to watch all of *Zocalo* to 'see' the work: its sameness is part of the point, and the audience can come and go as the day unfolds. But while a brash, majestic building occupies Warhol's image, and the only change in the film is caused by the play of light (natural and artificial competing for kitsch effect), in *Zocalo*, the square — the presumed subject of the work — is cut off, seen only in part, and even the flagpole has been severed at half mast. It is the public, not the monument, that is the subject of the work and through which time is manifest. Deleuze

has suggested that rather than thinking of ourselves or our actions as 'in time', we should think of time as being 'in us' or 'in them' in a way that may divide us from our given selves (private and public).[2] This awareness, then, exposes us to other worlds, other possibilities, other paths and trajectories. Unlike *Empire*, it is the internal temporality of *Zocalo*'s inhabitants, their unfamiliar 'other' time, that is the basis for duration rather than the mere fact of its length as evidenced by the twelve hours of video.

The tempo of *Zocalo* matches the tempo of Alÿs's other works, in particular his walks through cities. The walks are structured by journeys, activities, or narratives, and Alÿs seems to use his own presence, his own time — or that of the character or idea he is embodying — to make apparent the time of his chosen location. While Alÿs himself is absent in *Zocalo*, the indication of 'other' time is achieved through the setting of *Zocalo* itself. The plaza or city square is a common feature in many countries, but the manner of its occupation and use is particular to a given location. In *Zocalo*, the peculiar combination of purposeful movement and indeterminate stillness is indicative perhaps of what Alÿs has described as Mexico's ambiguous relationship to modernity: a wavering affiliation that has yet to be fully realised.

Space Time
On the roof of a residential building, an empty billboard sits expectantly. The light reflected in the blank metallic surface is at first so bright that it is uncomfortable to look at the scene for too long. Much in the same way that we turn away from the sun, the intensity diverts us to examine the surrounding view. In the misty half-light that suffuses the air around the reflective surface, we can make out only vague forms. The billboard monstrously dominates the roof, waiting for its own image to be projected onto the blank surface that for now acts like a temporary floodlight for the unseen surroundings. One imagines that from afar, its enormous reflective surface must appear like a second, all too man-made rectangular sun vying with its natural competitor for blinding luminosity. As the sun's angle changes, the billboard's surface becomes muted, simultaneously revealing details of the adjacent architecture. The tired façade of the building is marked by irregular features: a home-made-looking balcony hangs on one side; air conditioning units protrude unexpectedly; and the patchwork surface of the overall structure which suggests a building that offers little more than habitation. As the sun continues to move, the billboard takes on the appearance of a flat, white nothingness, a vast and abstract emptiness whose three-dimensionality

Francis Alÿs *Zocalo. May 20, 1999* 1999

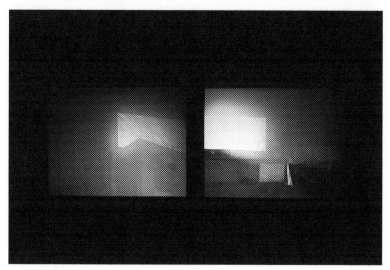

Anri Sala *Blindfold* 2002

begins to seem uncertain — this harbinger of material desire itself becomes immaterial. The unexpected appearance of a woman on the balcony reminds us of the 'real time' of the scene, her quick domestic movements interrupting the otherwise static vista. But immediately above her unsuspecting figure, the vacuum of white space threatens to swallow up the image completely, returning the screen to its original blank surface.

A second similar scene, but here the billboard is propped above a low wall adjacent to a road. The light coming from behind is again blinding as it hits the metallic surface of the empty hoarding. Aside from the vacant plot of land in front, a wasteland of rubble, a rough pedestrian path has been worn down at the side of the road. The fuzzy shapes of passers by can be made out in the glare. The sound, a fairly abstract accompaniment to the other image in Anri Sala's double projection *Blindfold* (pp.17, 63–5), here does not emanate from, but occasionally illustrates, passing cars, a revolving bicycle chain, and the voices of pedestrians. This street sound is interspersed with staccato violin playing, a series of notes that seem to reflect the intense light and create a vague impression of suspense. While the image remains obscured, one is aware of a far greater reliance on sound to 'read' the projection: this imagined 'aural space' is constructed out of the frequency of the cars, the pace of the pedestrians, and the unpaved ground. The work suggests a place of uneven economic development, where walking remains a primary means of transport, and the built environment is in transition, the semi-constructed surroundings exposing a half-state that could indicate either economic 'progress' or 'recession'. The vacant billboard is a portent of change — though it is unclear if its emptiness is an indication of failed or future possibility. One imagines the effect of an image within the image, projecting onto the blank surface the glossy totality of an advertisement, its sign language not yet in sync with the surrounding economy.

Blindfold was filmed in two locations in Albania: Tirana and Vlora. This information is not provided and, perhaps, is not necessary, as one could argue that the scene is representative of a type of social and economic change that can currently be witnessed in many locations. This type of transition is neither steady nor consistent, and is violently dependent on the vagaries of a global economy. That *Blindfold* could refer generically to cities in Albania, Brazil or Turkey, however, is an assumption based on a standard version of the story of modernity — as a narrative of progress emanating from Europe — and represents a discursive victory of time over space. According to this line of thought, all places are understood in relation to 'advanced' Europe

and fall somewhere on a continuum of 'behind', 'backward', or in more recent terminology, 'developing'. This type of categorisation eradicates the spatial, denies difference, and cannot conceive of 'other temporalities' (other, that is, than the progress towards modernisation or development in the Euro-Western model). Alternately, both *Zocalo* and *Blindfold* point to the continued existence of temporalities, as opposed to uniform time. The works highlight a presence of place or space where specificity (local uniqueness, a sense of place) derives not from some mythical internal roots, nor from a history of relative isolation (now to be disrupted by globalisation), but precisely from the particularity of the mixture of influences to be found there within.

It is less surprising then that both Alÿs and Sala make use of natural time in order to structure their work (the twelve hours of *Zocalo* and the sun's relative position to the artist/camera lens in *Blindfold*). The return to natural time in these works seems to be part of an argument for increasing complexity in the understanding of local specificity. It is generally accepted that the invention of the clock put the sun 'out of order', forcing people to live not according to the rhythm of nature but to a new mechanical beat. This transformation formed the main axis within the process of the emergence of modern time-consciousness and modern space-time conception in Europe. Until the uniformity of the techniques of measurement achieved by the mechanical clock found its expression in social organisations, time had always been thought in relation to a definite space. In such pre-modern societies, Anthony Giddens has observed, 'no one could tell the time of day without reference to other socio-spatial markers: "when" was almost universally either connected with "where" or identified by regular natural occurrences.'[3] Along with the mechanical clock came the dissolution of time-space unity: 'The separating of time and space,' Giddens continues, 'and their formation into "empty" dimensions cut through the connections between social activity and its "embedding" in the particularities of contexts of presence.'[4] In pre-modern times, then, time was described by a sequence of successive events or the chronological order of occurrences in a definite place. Space, alternatively, was an area spontaneously or intentionally organised by some kind of activity — personal, communal, etc. Space and time, therefore, were only conceived socially and only within the society that created them. In modernity, in contrast, time and space are defined as separate categories with their own units of measurement. Time is not represented by a natural event but by the universally valid hour and its subdivisions and space is represented in its three-dimensionality by geometrical-mathematical constructs.

Alÿs and Sala's questioning of this uniformity of modernisation is a complex celebration of the continued existence of space or place. While their work could be read as an argument against the easy assumption of global sameness — the type of flippancy that merges Berlin, Bamako and Bangkok for commercial alliteration — it might also be read as an alternative imagining of space and time that recognises the ruptures, inequalities and structural divides within them. The geographical differences portrayed in their works do not represent a case of some countries needing to 'catch up', but are instead reflections of deep inequalities produced by globalisation. Sala has described how becoming aware of this inequality results in an elaborate confusion about one's sense of place and time. Speaking of Albania he states:

> People start considering their own reality as surreal because it's
> different from the standards they wish to join. Their wish for
> 'normal' or, lets say, 'European' reality is so strong that their
> present reality is qualified as surreal. This constant judgement
> between 'there' and 'here' creates a kind of comical geopolitical
> depression. But what they call 'surreal reality' is the reality they
> produce themselves everyday. [5]

Alÿs and Sala are not alone in their apparent scepticism of the dominance of modern, mechanised time. Other recent works have similarly revealed the potential coexistence of temporalities and spatialities within and between place. Fikret Atay's *Rebels of the Dance* (pp.21, 28–31) takes place in what might be described by Marc Augé as a non-place: an automatic teller booth. Void of furniture and occupied only by the plastic and metal surfaces of functional architecture, these rooms have none of the qualities we normally associate with interior space: they are purposefully unwelcoming in order to reduce the amount of time spent inside and thereby increase efficiency; they are constantly surveyed to prevent any sense of privacy and to discourage anything other than their intended use; and they are only accessible through ownership of the card that hopefully ensures one's purposeful visit and quick retreat. Atay's co-option of such a setting for his work is therefore all the more striking given that the video was shot in his hometown of Batman in eastern Turkey. The booth was not one of the thousands available in a Westernised metropolis but one of the few jarring effects of the presence of the oil industry in this otherwise economically poor area.

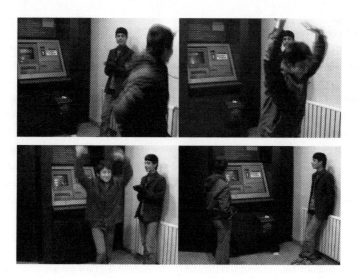

Fikret Atay *Rebels of the Dance* 2002

Atay's own presence as director/artist is made apparent from the outset of the film when, from inside the booth, he invites two young boys, who are waiting with others outside in the dark, to enter. The boys, clearly friends, begin to sing a song that, though improvised, is structured by a familiar and traditional form. Wavering between self-consciousness in front of the camera and moments of total absorption and enjoyment in their act, the boys' performance is somehow in defiance of the anonymity of the space, whose absurdly unrelenting mechanisation seems to be reflected in the flickering insistence of the cash machine screen. The initial antagonism of the antiseptic environment is ameliorated by the boys' infectious enthusiasm for their song. The boys' use of the space alters the hermetic efficiency of the booth, and with time the lighting, acoustics and even the madly flashing screen appear to be in harmony with their act. It is no longer the boys' 'incorrect' use of the space that strikes the viewer but their total co-option of it. Like Sala's billboard, which serves as a tangible sign of the often invisible presence of economic globalisation, the neutrality of the automatic teller booth, a material sign of global economic flow, is revealed to be vulnerable to reinterpretation, its impartiality open to corruption. The competency of the time of the ATM space where one's receipt records the moment of transaction — the nanosecond of computerised exchange — is disrupted by the uncircumscribed time of the extemporised song that lasts just as long as it should.

Projected Time

The conflict of past, present and future, as embodied in social and material economies, constitutes one investigation of time within these works so far discussed. Another, which stands outside of content, but which is no less significant for our ability to determine meaning, is the time of the video or film projection itself. While our traditional museum experience provides autonomy over the time of viewing — we come and go as we chose, the painting or sculpture remaining the same — the video projection denies us this authority. We are victims of its timing. Groys has described the encounter of projected images in the museum space as akin to the experience of images in real life, where 'we lack the autonomy of command to access them at will'. He continues:

> The museum visitor now finds himself back in a situation similar
> to outside the museum, returned to that familiar place we all
> know as somewhere where we constantly miss out on anything
> of importance. In so-called real life, one is forever haunted by
> the feeling of being in the wrong place at the wrong time.
> If during a museum visit we interrupt our contemplation of some
> video or film work in order to return to it at a later point, we will
> inevitably be filled with that very same feeling of having missed
> something crucial and will no longer be sure what is really
> happening in the installation.[6]

Our knowledge of the projected video work, he argues, is always partial, and our understanding remains incomplete.

In contrast, with cinema, the viewer is forced to remain in their seat and watch from beginning to end; this immobility is compensated for by the constant agitation of the image. We succumb to the entrapment and are rewarded with action. Indeed, we recognise film and video as art (as opposed to cinema or television) by, of course, its presence in the museum, but also, the characteristic speed or slowness of the image. But what if the museum-goer is forced to undergo the structure of the cinematic screening in a de-contextualised form within the gallery space? In order to see the film work of Jeroen de Rijke and Willem de Rooij, for example, the visitor sits in a minimal, dimly lit space, waits for the projection to begin at an allotted time, experiences latent pressure to watch the film in its entirety, and is thus exposed to the precisely defined beginning and end of the film.

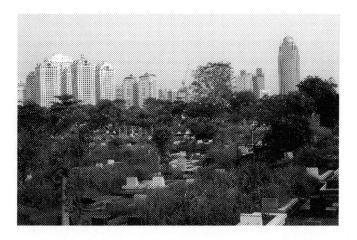

Jeroen de Rijke and Willem de Rooij *Untitled* 2001

So the distracted and discontinuous viewing experience described by Groys above and analysed eloquently in this book by Peter Osborne, is perhaps circumnavigated. De Rijke and de Rooij's films, however, have none of the motion we associate with cinema, and are instead characterised by stillness: not only are the angle and movement of the camera and the editing kept to a minimum, but the presence of action or narrative is negligible. It is not that the artists represent slow time, merely that they have us watch real time in real time with the resulting impression that the image has been slowed. In fact, it is only we, the viewers, who have stopped or reduced movement.

It has been argued that both Stan Douglas' and Douglas Gordon's use of decontextualised film material in video installations allows the audience to analyse and dissect film in an environment free from the pathos and entertainment of the cinematic space. In such a way, their videos could be said to educate an audience in developing the skills necessary to scrutinise film, a theoretical framework, perhaps, for future experience. For de Rijke and de Rooij, the cinematic-style screening, the minimal surround of the gallery space, and in particular, the absence of image for a period of time between projections, can similarly function to alert the viewer to the work's own formal and structural qualities. Moreover, these aspects can together begin to formulate a critical framework from which one can examine the normative presentation of video in the gallery setting — the looped video projection — and, perhaps more ambitiously, question the museum viewing experience and of the act of seeing itself. De Rijke and de Rooij give almost equal importance

to the times of projection and non-projection in their work, the latter frequently lasts longer. The periods of blankness are intended to be anything but. The space (there is no screen as such) is without a filmic image but its emptiness leaves room for an after-image and the process of mental projection. The artists' insistence on pause, reflection, and a heightened awareness of the cognitive labour required for perception, calls in to question the hidden structure of the looped image that is generally entered into at random, and keeps time only with the hours of the museum which dictate beginning and end.

Though the regulated time of screenings and the use of film by de Rijke and de Rooij suggest a cinematic corollary, the empty gallery, dimly lit and occupied only by the projector and benches, bears no resemblance to the proscenium seating, plush fabrics and staged screen of the movie theatre. Instead it deliberately references the archetypical white cube art space. In its empty state between projections, this setting makes starkly apparent the space of the museum and the tropes of modern gallery architecture: the mannered construction of the viewing experience; the uniform whiteness of the walls; and the deliberate absence of distracting detail. De Rijke and de Rooij, I suspect, are not interested in revealing the presence of such formulas in order to re-define the white cube, nor to critique it in favour of the demystification or popularisation of space. Indeed, quite the opposite. Their framing of the 'secular temple' museum type is intended precisely in order to reassert the significance of viewing and the act of seeing that such a mode of presentation recommends. The concentration that the installation requires is then applied to the characteristically minimal films. For instance, in *Untitled* (pp.23, 35), a ten-minute, silent, colour, 35mm film, this impression of reduction is amplified by the lack of sound and the extreme flatness of the picture plane. Shot from a small hill opposite, the foreground dominates two-thirds of the frame and is occupied by a lushly overgrown cemetery. Gravestones poke through the thick grass interspersed with flowering trees that form a band in the distance separating the cemetery from a skyline that is abruptly punctuated with towering high-rise constructions. These pallid grey and white buildings merge with a milky sky. The lack of horizon gives the scene its almost hostile flatness, which is only somewhat interrupted by the movement of the grass in the wind and the appearance of visitors in the cemetery. The extremity of the contrast — dense vegetation and the surprisingly benign presence of death versus the uniform appearance of the pattern-book high-rises and the polluted-looking sky — seems incongruous with the structure of the silent film and the minimal surrounding of the

projection space. The obviousness of the poignancy of the disparity evokes the sense of a *momento mori* in its symbolic pairing of rampant commercial expansion and the inevitability of ephemerality. Not only does the apparently politicised image appear oddly out of place in the minimal surround, but it is also precisely the type of reference to an 'other world' outside the white cube that one does not expect in the Judd-like treatment of the space. The disparity suggests an acknowledgement of the hermetic impossibility of a minimalist work within the realm of a culture-industry of spectacle, as well as a simultaneous desire for the retrieval of critical viewing from the corrosive effects of the excessive production of images.

In the case of *Untitled*, and indeed as is often the case in de Rijke and de Rooij's chosen subjects, the stillness of the image betrays the amount of information it contains, information that we generally expect, when viewing films, from the constantly changing picture. *Untitled* reveals references to the histories of colonialism, capitalism and circulation. The city in the background is Djakarta, and the rapid expansion of this Indonesian capital (as evidenced by the construction) has been largely the result of the Chinese population who occupy a dominant but polarised position in the economy. The graveyard is not simply allowed to remain untouched by this expansion for its sentimental or religious value, but instead, because it is the burial site of the wife of the first President of Indonesia, Ibu Fatmawati Soerkano, who, tradition has it, sewed by hand the first Indonesian flag. Knowing that the artists are Dutch, we assume a post-colonial interest on their behalf. The impenetrable flatness of the image, however, suggests that this observational investigation of a former colony remains a halted quest for understanding.

The Eternal Return

One could argue that the controlled time of the screenings of de Rijke and de Rooij's work, removed as it is from the normative and independent time of the museum visit, serves to reinforce the stillness of the tempo of the films themselves. It is a strategy made meaningful precisely because of its relative singularity (if all artists chose to present their work in this way the gesture would become meaningless), and because of its disruption to many museums' current agenda of 'easing' visitor experience. But perhaps the distracted reception of video is not merely the inevitable result of the experience of video projection wandered into at random and never fully absorbed (as argued by Groys), but in fact, symptomatic of a general mode of observation, and the appropriate viewing tempo for our contemporary culture.

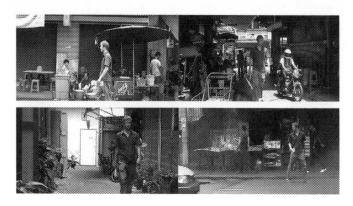

Bojan Sarcevic *Untitled (Bangkok)* 2002

The looped image, then, might present a certain stabilising aspect in the otherwise uncontrollable experience of time in daily life. Continuous return keeps everything in a state of agitated stillness, leading nowhere. Unlike the vanitas-style image of de Rijke and de Rooij, the 'loop' no longer leads inevitably to death and dissolution.

Bojan Sarcevic's *Untitled (Bangkok)* (above and pp.76–9) maps the artist's short circular walk through the streets and alleys of Bangkok. Beginning and ending at a street-vendor's stall, Sarcevic walks with steady purposeful-ness, and is filmed by two cameras that track his advance and recession. Watching the artist return to the point of departure, only to start all over again, one is aware of an imaginary line drawn by Sarcevic's movement through the city. The effect of the endlessly repeated walk is to reinforce the sense of unbridgeable separation that appears to exist between the artist and his surroundings as he walks — apparently unnoticed — by the people on the street. The endless repetition of the scene on a looped DVD, with, of course, no change over time, presents an image of difference, distance and lack of communication. Sarcevic's presence as a Westerner is apparently so outlandish that he is rendered invisible, of no significance in the day-to-day life of the Thai back-streets. Like the inhabitants of Zocalo, or Alÿs's own presence in the walks he has undertaken, Sarcevic embodies an 'other time', here, however, so completely divorced from the locale that it seems to create a space unto itself. A magic border demarcates his figure and displaces his being completely. While the existence of such a pronounced difference in temporalities seems on the one hand to reassuringly confirm the limits of global homogeneity, it also demonstrates a disturbing lack of empathetic

interest, a non-acknowledgement that offers little hope for future mutual understanding. Sarcevic's circular route reminds us of the Sisyphusian task of empathetic understanding and the repetitive reinscription of disparity that leaves us hovering endlessly, recycling our now jaded aspirations for a global society.

1 Boris Groys (ed.), 'The Speed of Art', in *Peter Fischli, David Weiss*, exh, cat., Walker Art Center, Minneapolis 1996, p.119.

2 Gilles Deleuze, 'Four Poetic Formulas That Might Resume Kant', in *Essays Clinical and Critical*, trans. Daniel W. Smith and Michael A. Greco, Minneapolis 1997.

3 Anthony Giddens, *The Consequence of Modernity*, Cambridge 1991, p.17.

4 Ibid., p.20.

5 In *Anri Sala*, exh. cat., Kunsthalle Wien, Vienna 2003, pp.52–3.

6 Boris Groys, 'On the Aesthetics of Video Installations', in *Stan Douglas*, exh. cat., Kunsthalle Basel, Basel 2001, n.p.

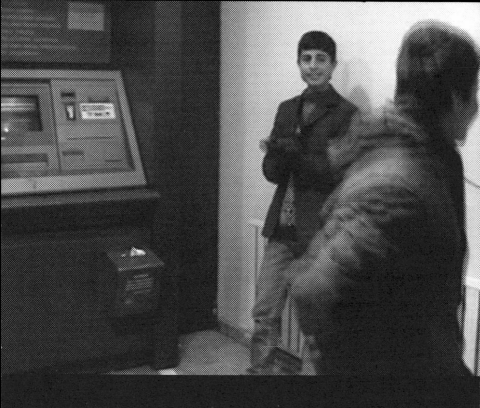

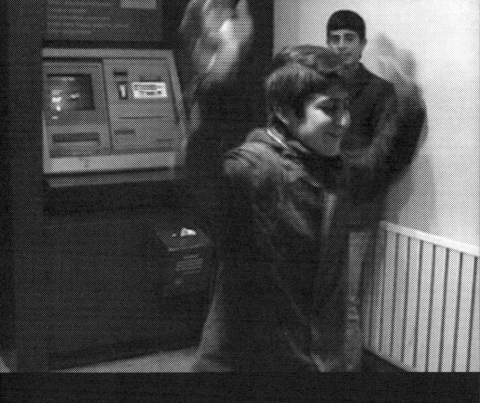

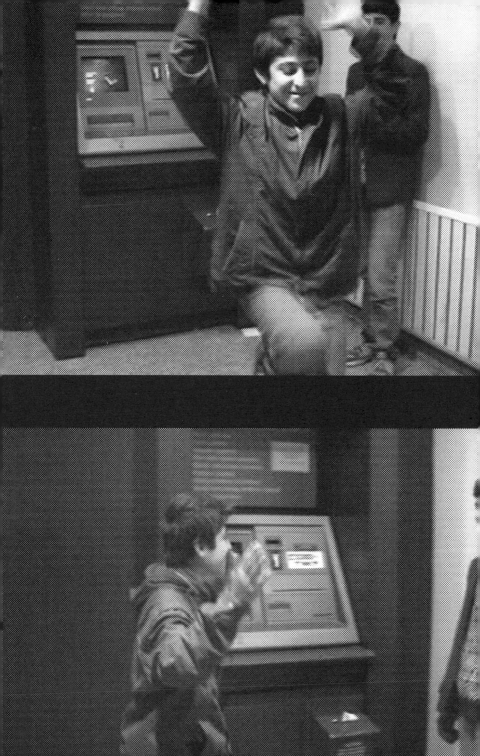

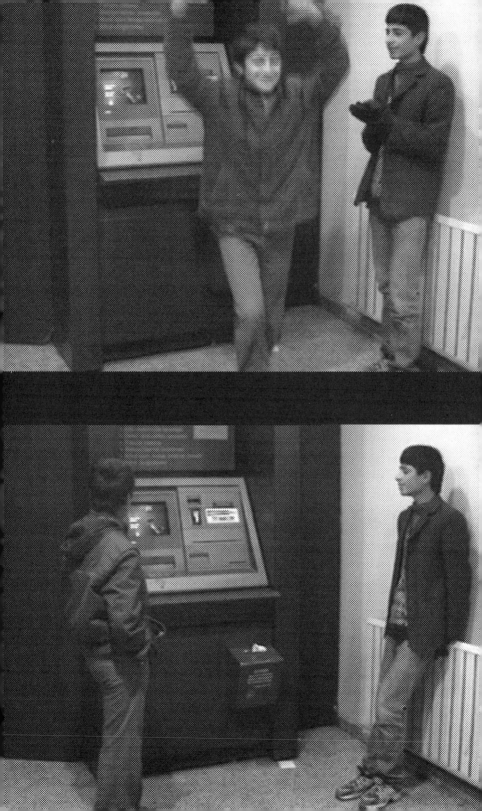

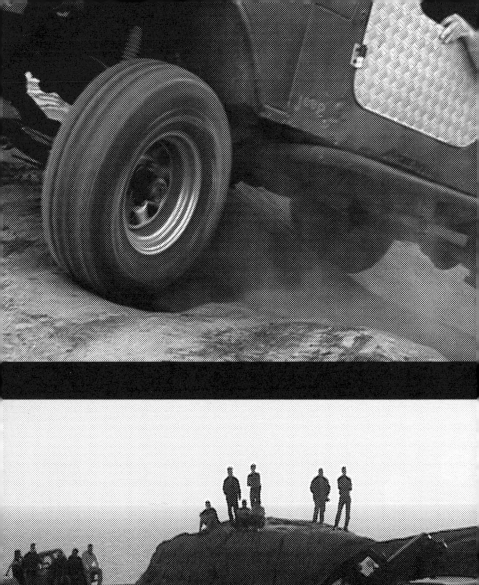

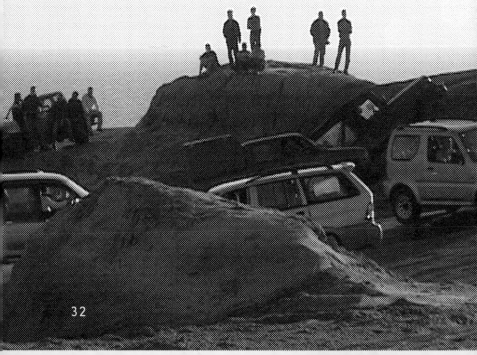

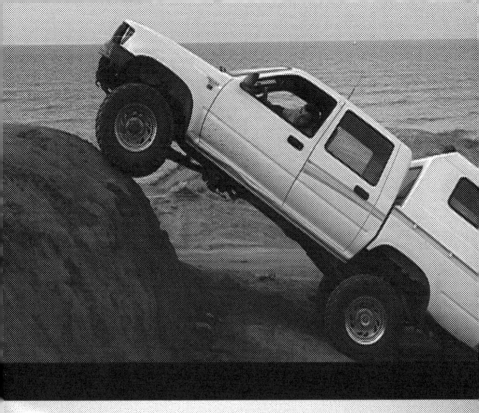

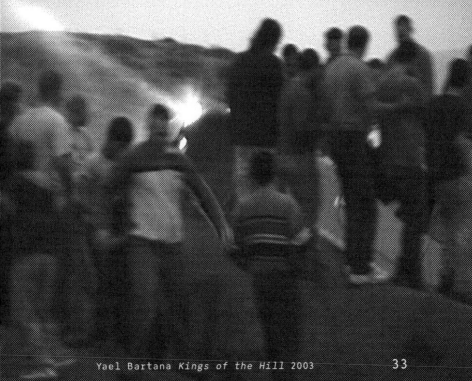

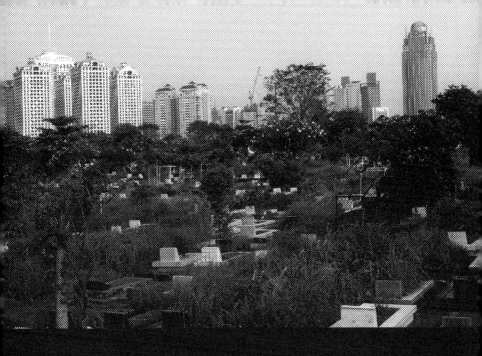

Gregor Muir

CHRONO-
CHROMIE

To provide a context for contemporary artworks that address the experience of time, it becomes necessary to recall some of the earliest films ever made — works such as the Lumière Brothers' *La sortie de l'usine de Lumière à Lyon* (Workers Leaving the Lumière Factory, 1895) and *L'Arrivée d'un train en gare de la Ciotate* (Arrival of a Train at La Ciotat, 1895) — flickering images of people with little idea of what it meant to be captured on film. The Lumière films were often recordings of actual events; indeed, the Brothers' fifty-second films, of which they produced over 1500, were called 'actualities'. Along similar lines, Alexander Promio's *Liverpool Docks [La Rade; Entrée dans Clarence Dock, Panorama pris du chemin de fer électrique I–IV]* (1896) provides us with a rare example of a series of actualities spliced together to give an overview of a youthful Merseyside. Born in 1868, Promio worked alongside the Lumière brothers as cameraman and projectionist, but between 1896 and 1898 he also toured Europe, shooting and screening his films as he went. His scenes of social significance and views of unpretentious settings continue to attract comparison between actualities and the later emergence of documentary, taken from the term 'documentaire', which initially applied to travelogue film-making.

William Kennedy-Laurie Dickson's *Panorama of Ealing from a Moving Tram* (1901) sees the camera positioned once more as roving eye, an observer of everyday life. Originally photographed using a 68mm electric camera running at forty frames per second, the film lasts two minutes and shows the view from the upper deck of an electric tram on the day that Acton became a designated London borough. The film occupies a twofold condition, being symptomatic of the socio-economic advancement of the day as well as the means to record it. In general, the early camera recorded a range of subjects: ordinary matters related to the workplace and the home, feats of technical engineering, and impressive views and panoramas.

During the 1920s and 30s, Soviet Cinema made every effort to put film to work and present it as a more desirable form of popular entertainment. The continuing cinematic struggle in film production between realism and expression saw the erosion of any interest in actualities in favour of the tactical suspension of disbelief, often with leanings toward propaganda and the urgency of a state message. New techniques such as photo-montage, suture, and behind-the-scenes wizardry would see the inevitable slide of cinema towards Hollywood. By the late 1930s all films were subject to being edited so that a story might unfold. As noted by film critic André Bazin in 1958, 'the story was unfolded in a series of set-ups numbering as a rule about 600'. [1] By the 1930s, the state sponsored Documentary Film movement in London sought to pursue the 'creative treatment of actuality' [2] through the production of films with a higher social purpose — principles that would later fracture as the movement veered between wartime propaganda and wide-eyed Marxism.

In the post-war era, the fashion for staccato-like editing was challenged by the likes of Orson Welles and William Wyler, who saw the potential of 'depth of field' shots — another version of the real-life viewing experience whereby a series of actions and developments would unfold in one take. Cinematographer Gregg Toland's use of depth of field in *Citizen Kane* (1941) allowed elements of a single scene to remain in focus from a distance of around two feet up to infinity. This all-encompassing field of vision affords the eye the potential to drift across the screen and focus on events as it might in real life, or at least give the impression that this may be the case as sometimes the image is punctuated by a series of narrative cues taking us from one part of the storyline to another. What then, if the narrative is removed altogether and the eye receives no directional pointers? Moreover, what if there is no central subject, no single point of focus — are we to assume that the eye is apt to settle as it sees fit? In recent years, artists — fixated with

film and television — have played with the notion of narrative; sometimes through the exploration of non-narrative or ambiguous narrative structures, or through the removal of narrative in favour of fixed static shots that in many ways recall early actualities. Certainly, there are artists working today who seem to encourage the viewer to engage with the work through a form of retinal surfing.

Jeroen de Rijke and Willem de Rooij's work provides us with an example of this type of visual wandering. Shot in the Indonesian city of Djakarta, *Untitled* (pp.23, 35) is a single take of a graveyard in Djakarta beyond which skyscrapers loom on the horizon. (The work recalls their earlier film, *Bantar Gebang* (p.39) — a single shot of an inhabited rubbish dump on the same city's outskirts.) Sensing the location was lacking something, the artists arranged for a group of individuals to sit under a tree, recreating a scene from a previous visit. On close inspection, a man can be seen digging a grave, for real, and members of the public occasionally stroll through the graveyard's abundant greenery. The camera is positioned on top of a wall, and the 35mm colour film has no edits, pans nor audio (which again connects the two films in as much as they are both shots of walled enclosures). As with *Bantar Gebang*, it runs uninterrupted for ten minutes. According to Diedrich Diedrichsen:

> The picture flatly confronts the viewer, offering no point of
> identification. Neither perspective nor sounds invite the viewer
> to enter into the picture or to construct a story to go with it.
> One's gaze is concentrated on an image in which the merest
> movement in the planar, geometric layout becomes an abstract
> art. The motion of plants in the occasional breeze call to
> mind the smudging of paints on a canvas, and the figures that
> move here and there through the image, not much larger than
> pin-heads, seem like lines being drawn through a painting.[3]

While the fixed viewpoint presented by an artist or film-maker should always be questioned, and the viewer should consider why this shot in particular is being presented, it remains up to us to make our own observations within the frame. To be left alone with a depth of field shot of a scene in which nothing conventionally exciting occurs might be said to be empowering given how we naturally tend to attach meaning to our own observations. Such a viewing experience may require some adjustment on our part, especially as the eye is being put to work in different ways than called for by

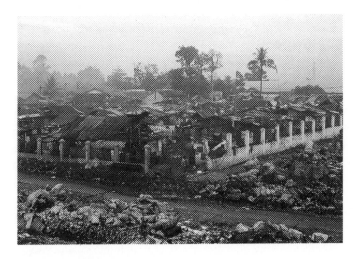

Jeroen de Rijke and Willem de Rooij
Bantar Gebang 2000

narrative film. Being encouraged to make our own observations and to become more observational in our reading of the image defies conventional narrative structure, or, as some may argue, rejoins it on another level, a more cerebral one.

The work of de Rijke & de Rooij exacerbates its own sense of vacuum, and various attempts have been made to assign it meaning. One tactic for unravelling the image has been to consider the historical references contained within: the graveyard is the resting place of the first President of Indonesia's late wife; the skyscrapers under construction in the background are the product of enterprising Chinese developers; and Djakarta is a city associated with high unemployment. While these facts allude to the artists' often understated political interests, the work can also be read as highly self-reflective and concerned with compositional construction, random movement, time and space. As an extension to the composed space of the image, a 'blank' period of several minutes follows each screening, during which time the room is left purposely vacant. It is a condition of the work that there be long periods *sans image* between screenings so that our critical faculties are directed toward the physical order of the room — a form of expanded spatial awareness that asks us to consider the actual space of the gallery.

Non-narrative films that use depth of field might be said to have a democratising effect on the eye. These works represent, perhaps, a form of film-making

that is most closely related to pure abstraction, not in the literal sense of 'abstract film', but in the way the eye scans the surface of an actuality recording. We attempt to read the image according to what attracts us, our eyes darting from one region of the screen to the other. Our overall impression of the work, however, does not wholly reside in individual interpretation. While two people sitting next to each other may experience events differently — which might suggest that a different narrative is being experienced by both — a time-based work nonetheless embeds itself in our psyche through its lasting image and temporal afterburn. It is this specific sense of time that is relayed when a work engages its audience through a heightened state of awareness.

The videoworks of Fikret Atay encourage us to read into minor observations, no matter how slight, and over time reveal a great deal about their subjects and settings. *Rebels of the Dance* (pp.21, 28–31) shows two young boys performing what appears to be a traditional dance within the confines of a cash machine lobby. Filmed in the repressive oil-refining town of Batman in Eastern Turkey, the choice of a cash machine lobby — a corporate space designed through convenience and, as a result, largely uncared for — is bleak. (One can't help but notice the burn marks where individuals have rested cigarettes while pumping in PIN numbers.) In this setting, the boys perform their own mischievous rendition of local custom — they launch into a stream of synchronised chanting and polyphony, revealing no words but for some Kurdish phrases at the end: 'Who is the Pasha? Who is the Groom?' In the absence of other lyrics, the two seem perfectly attuned. Through some hidden code they are able to keep up with each other, using both made-up moves and elements of ritual dance. The boys are in sync, yet we as viewers feel alienated. In an attempt to extract some hidden meaning, we enter into a heightened state of awareness, consumed by every detail, every clue.

Anri Sala's *Blindfold* (pp.17, 63–5) is a two-screen video projection of light reflected from two aluminum billboards in two different locations in Albania — Tirana and Vlora. At first sight, the location of these billboards is indeterminable — many people have commented on how the setting could be either Brazil or Turkey, both indicative of an underdeveloped region giving way to consumerism. As the sun slowly passes across the billboards, the surrounding image — which we long to determine — is finally revealed through the haze. One of the billboards is parked above a low-cost building, the other is placed next to a ramshackle road. Again, our sense of perception is heightened to the extent that we notice every detail of the building's façade, as well as every car and, more likely, passerby. We grasp at the facts as soon as they

arrive — our sense of anticipation teased by a suspenseful soundtrack of plucked violin. While we experience the time it takes for the sun to pass across the face of the billboards, we also experience the passing of time at that place. Furthermore, there isn't the same pace of activity as we might expect from other towns or cities, and time seems to be remarkably slowed down. As Sala observes: 'I like to film the slowness of the sun. Cities in Albania are not like New York, Paris, or other big cities — they live slower.' [4]

Surveying a long, unedited shot seems to be an increasingly prolific mode of watching contemporary film and video art. Many put this down to the revival of interest in documentary film-making. However, there may be other influences to hand, namely the wealth of surveillance material which we know to be in constant production. Abstract surveillance footage filters through to our daily lives with increasing regularity. (I am reminded of late-night German TV that soothes its audiences by broadcasting endless unedited shots of train journeys through dormant villages, views from passing satellites, or early-morning scenes of alpine resorts.) Artists in particular continue to acknowledge the connectivity between lens-based media and surveillance, as well as the ability of moving image to survey matters of the artist's choosing. One of the key conceptual film-works of our time, Andy Warhol's *Empire* (1964), might also be called into account for adopting some kind of endless surveillance as a strategy with which to make a film: one of the earliest to venture beyond our ability to concentrate.

JOHN PALMER: Why is nothing happening? I don't understand.

HENRY ROMNEY: I have a feeling that all we're filming
is the red light.

ANDY WARHOL: Oh, Henry! Jonas [Mekas], it's your turn to say
something — you're being written down.

JOHN PALMER: Jonas is changing the films just like me.

HENRY ROMNEY: Andy, now is the time to pan.

JOHN PALMER: Definitely not!

ANDY WARHOL: The Empire State Building is a star!

JOHN PALMER: Has anything happened at all?

MARIE MENKEN: No.

JOHN PALMER: Good. [5]

At the beginning of the twenty-first century, our consideration of cinema is no longer as attached to moving images as it once was. The arrival of the

electronic image, and the consequent erosion of cinema's important position as a carrier of moving images, has prompted a shift in values and interests. Television's role is also being challenged by the presence of new technologies and agents such as the Internet, which already carries the news and many other forms of video entertainment. This shift in our perception and relationship to the moving image, in all its present diversity, is accompanied by the acceleration of technologies towards enhanced financial and functional efficiency. The end result of such advancement is reflected in the work of those film and video artists who are able to capture real-time events for considerably longer durations. Ironically, however, high-speed technologies seem only to reveal our desire for near-stasis in the image. We relish the fact that we can record the world in real time ad infinitum — an incident as ancient as the passing of the sun can now be recorded in a professional digital format — but the resultant images are ones of stillness.

Speed, the locus of twentieth-century enterprise, no longer dominates. The twentieth century's desire for speed (faster processes, faster production) has delivered us into the digital age. While this age also requires speed (faster downloads, faster processing) it does not demand that speed be experienced as in-your-face fast. Speed is no longer a physical presence, but it resides instead at a sub-atomic level in a stream of electrons. Speed is no longer culturally represented in heavy metal analogue machinery, but instead in high-speed communications and data processing (even though we still need heavy metal machinery to underpin power-hungry digital technologies).

Given the advancements of recent technology, one of the more telling stages of our 'digital revolution' is the invention of webcasts, and our ability to send and receive moving images over the Internet. In recent years, live webcasts have begun to offer worldwide views that — despite transmission staggers and poor quality — enable us to observe downtown San Diego, uptown Banbury, or the inside of a bar in Alice Springs. But although we have access to a variety of locations, in essence, all webcasts are the same. They are fixed-frame surveillance shots; they are the return of actualities, in digital form, one hundred years on. Strangely enough, webcasts often run at a slower rate than the Lumière's sixteen frames per second — coincidently, the same rate as Andy Warhol's *Empire*, which was consciously shot at a slower frame setting to afford longer duration.

Webcasts have a number of distinct qualities. There is no cameraman, no author, and no narrative. Once the camera has been set up, the image runs indefinitely to the point where it can no longer be watched from beginning to end.

We accept that webcasts cannot be seen in their entirety and that they continue to function when they are not being watched: the viewer is rendered remote, and for the most part is understood to be absent. Finally, webcasts are endless recordings of supposedly live events, which are, typically, eventless.

Webcasting, or 'live-cast', reminds us of live-video works of the 1960s and 70s, like Yoko Ono's *Sky TV* (1966) and Dan Graham's *Opposing Mirrors and Video Monitors on Time Delay* (1974). Since Warhol's revolutionary *Empire*, viewers are no longer expected to see everything all the way through. And, in the case of art forms derived from a live feed, viewing something all the way through is impossible. With certain long durational films we believe we have seen the film once its rhythm has struck itself on our psyche. 'Have you seen Warhol's *Empire*?' It is intriguing that many say 'yes', even when they haven't watched the entire piece. But like computers, we have limited memory, and, as reflected through *Empire*, our cultural standards allow us to catch it, gauge it and leave.

Looking at Wolfgang Staehle's webcasts of the Empire State Building entitled *Empire 24/7* (2000), the television tower in Berlin (2001), or the Comburg Monastery near Schwäbisch Hall, Germany (pp.81–3), we can only see so much. What we experience during that time — or rather, the time we can spare — is a slice of a considerably longer-running work which we imagine to be infinite. In our present cultural viewing mode, however, we know that what we are seeing is only a finite moment of an otherwise infinite film. That we now live in a world where it is possible to turn the camera on and leave it running — coupled with the relative ease with which we can broadcast — marks a departure from modes of thinking previously reserved for finite storage technologies. Consequently, we are exposed to increasing amounts of moving image that has no beginning and no end. Video in particular has been afflicted by this tendency towards longer periods of shooting and increased duration in the final work. Take for instance Bruce Nauman's *Mapping the Studio (Fat Chance John Cage)* (2001) — a five-screen installation that plays out five and three-quarter hours' worth of surveillance material of the artist's studio at night. According to Nauman:

> Well, it felt like it needed to be more than an hour or two, and
> then I thought if it's going to be that long then it should be …
> well, it just felt like it needed to be long so that you wouldn't
> necessarily sit down and watch the whole thing, but you could
> come and go, like some of those old Warhol films. I wanted

that feeling that the piece was just there, almost an object, just there, ongoing, being itself. I wanted the piece to have a real-time quality rather than fictional time. I like the idea of knowing it is going on whether you are there or not.[6]

Fiona Tan uses anthropological film footage as well as her own documentary-style material to produce films such as *Lift* (2000), in which the artist is seen rising above the Amsterdam skyline held afloat by balloons. Anthropological films, particularly those shot by Western travellers at the turn of the last century, are a feature of the work — as exemplified by her occasional use of found footage shot on ancient stock. Tan interweaves this material with her own research, sometimes applying the rudimentary anthropology to herself and her perception of cultural identity. Works such as *May You Live in Interesting Times* (1997) bring together a wealth of found and created images in order to assess the artist's own multinational identity (she was born in Indonesia, raised in Australia, and has lived in Europe since the age of eighteen).

While in Japan in 2000, Tan found a postcard revealing women archers wearing traditional dress and taking part in the annual Toshiya ceremony which has been held in the Sanjusangen-Do temple for over four hundred years. The finest young archers come to Kyoto to celebrate their passing from childhood to adulthood. On the Coming of Age day, these archers practice Kyundo — a Japanese style of archery which is not so much about hitting a target, as an exercise in fluidity and smoothness. Having returned to Amsterdam, where she presently lives, Tan became determined to film the ceremony and spent considerable time gaining permissions and planning the shoot. The following year, Tan returned with her crew. She describes:

Mesmerised I gaze at the endless rows of women who appear
briefly and then after the second shot and short bow,
retreat silently from the podium. I lose track of numbers.
Their multitude, over eight hundred, overwhelms me. This must
be some Japanese idea of heaven I muse, and gaze absent-
mindedly at the shapes of girls' ears. In some strange way
I am reminded of large flocks of birds. The women perform
silently and elegantly as in a choreography; each kimono
more stunning than the last. The gap separating me from this
culture becomes even larger.[7]

Fiona Tan *Rain* 2001

The title of the finished piece — *Saint Sebastian* (pp.101–3) — takes its name from the patron saint of archers and soldiers. It comprises two films projected on two sides of a single floating screen. One half of the screen shows details of the young women's hair and brightly coloured kimonos, as well as shots of their faces, ears and the napes their of necks. The other side of the screen depicts the moment when the string of the bow is drawn past the cheek, and one after the other a young woman lets loose a feathered arrow. Environmental sound generated by the general hub-bub of the occasion washes over the film as we become compelled by the sense of timing associated with the ceremony as wave after wave of archer takes the stand. It is the sense of relaying a time in a place — a certain rhythm of events informed by ancient tradition — that is emphasised. Similarly, Tan's *Rain* (above), shot in Indonesia, hijacks all time and imposes its own sense of the leaden day. On two monitors, we view the same film of a downpour and a dog sat next to two buckets of water. The two projections are, however, out of sync, and thus the buckets are seen at various stages of fullness. The work is purposely edited to loop back into itself and to appear never ending — an exercise in perpetual melancholy.

Israeli artist Yael Bartana contemplates what it is like to live in a state that imposes militaristic rituals on its land and its people. Her work, however, rarely points at the state in an obvious manner; instead, she explores

how these militaristic tendencies have penetrated people's ordinary lives, even their spare time. *Disembodying the National Army Tune* (2001) is a sculpture consisting of a loudspeaker raised up and down a pole like an automated flag. The speaker plays the military anthem used in memorial ceremonies, only the sound emitted is an awkward vocal rendition. As we approach the work, the speaker is raised like a flag — a moment of mourning turned into a push-button event. In the video installation *Trembling Time* (p.47), Bartana captures the moment when the traffic on a Tel Aviv highway comes to a standstill in collective remembrance of the Day of the Fallen Soldier. People step out of their cars, suggesting a common occurrence. But what type of occurrence could literally stop the traffic? As stated by the artist:

> I am focusing on Israel in order to ask: what is this place where I grew up? How long will this troubled nation continue to perpetuate this pattern of ignorance? By manipulating form, sound and movement, I create work that triggers personal resonance. Intimate reactions have the potential to provoke honest responses and perhaps replace the predictable, controlled reactions encouraged by the state.[8]

Bartana's *Kings of the Hill* (pp.32–3) was filmed over a period of several weekends in a coastal region just outside Tel Aviv. Here we find men in a variety of four-wheel drive vehicles trying to negotiate the area's steep cliffs. As they struggle to ascend near-vertical dirt tracks, one senses a surge of testosterone. Chaotic scenes of the car attempting to climb insurmountable hills are interspersed with shots of the sea and sky, moments of relative stillness and quiet, and two cars parked side-by-side lookout lovingly over the sea. As night falls, an unseen car trapped in a pit with its headlights shining upwards roars like a snared beast. *Kings of the Hill* subtly alludes to Israel's troubled political climate — the vehicles' futile plight reads as a reflection of the political and territorial struggle occurring elsewhere in the Middle East. We question the usefulness of such a pastime, as well as the relationship of the state to its people and the people to its land. As militaristic rituals are passed from state to individual, it would seem that some citizens come to view their family car as a tank.

Bojan Sarcevic's videoworks complement his sculptural interventions that engage with the function and ethics of place and space. As with his sculptural practice, Sarcevic's videos often feature a free-ranging entity at play in an otherwise formal setting. Sarcevic appears drawn to elements

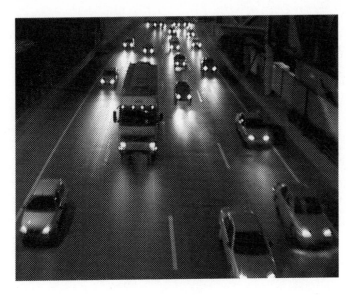

Yael Bartana *Trembling Time* 2001

that engage with a space according to a different sense of social purpose. For instance, in *It seems That An Animal Is In The World As Water In The Water* (p.48), he filmed a group of dogs in a church in Westerkerk, Amsterdam. Sarcevic described:

> A dog has no respect for places that are sacred in our mind.
> He barks where we would otherwise observe a respectful silence.
> But I don't envy the dogs' blind freedom and I think it's naive to
> consider this way of being an acceptable model. The dog presence
> in the church doesn't express a rebellion or blasphemous intention,
> but it allows me to set a critical distance in a relationship that
> naturally is submission and respect ... You must understand a
> sign is a sign, a building is a building, and value is not inside the
> stone but in the spirit that is free like a dog, since silence in this
> place is the most suitable for concentration.[9]

In Sarcevic's film *Untitled (Bangkok)* (pp.26, 76–9), we see the artist walking around the city, turning corners and crossing a busy main road before returning to the hustle and bustle of Bangkok's backstreets. The video is looped and gives a sense of repetitive perambulation reminiscent of

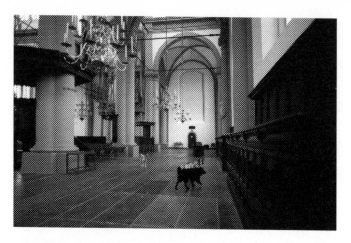

Bojan Sarcevic *It Seems That An Animal Is In The World As Water In The Water* 1999

Paul Auster's book *City of Glass* where the protagonist's ritualised Manhattan walks, mysterious throughout, are finally deciphered as using the city's grid system to spell out TOWER OF BABEL. On his walk, Sarcevic, who appears foreign based on his dress and conduct, is clearly driven by a different set of criteria to those that surround him (and by whom he is ignored). Outwardly, he gives off the impression of having no attachment to this place, no immersion in the city's codes. While commerce takes place all around him, he himself participates in no transaction, no exchange, and no interaction. The artist is invisible, unnoticed and unobserved.

Yang Fudong fuses traditional Chinese culture with contemporary Shanghai life. He makes videos of his Shanghai friends using digital handheld cameras, but his black-and-white films look as though they could have been made in the 1950s or 60s. This lexicon of traditional and contemporary aesthetics allows Fudong to play across a broad range of emotional responses. The superimposition of old and new is literalised in *Liu Lan* (pp.52–5), a film in which a young Chinese businessman in a white suit steps into a boat belonging to woman dressed in traditional colourful garb. The film's photography is classical and sumptuous; its mood is poetic, beautiful, and emotive.

Francis Alÿs's *Zocalo* (pp.12–13, 17) is a twelve-hour documentary of the main square in Mexico City, displaying a span from early morning into the evening. The camera was set at a fixed shot angled downward so that the base

of the flagpole boasting Mexico's largest flag is at the centre of the screen. The film starts in the early hours of the morning in darkness. Sunrise is greeted with the peeling of bells as the rush hour becomes increasingly evident. The public makes their way to work as carts are pushed through the square in preparation for the tourists who will soon stand in the shade of the flagpole out of the beating sun. At high noon, the shadowy line of the flagpole foreshortens so that the undulating flag provides the only source of shade in the square. The sun passes and the tourists line up again, taking their place on this vast public stage. At the end of the evening, troops enter the square to lower the flag. From afar, they resemble a perfect oblong shape in a landscape otherwise filled with random activity. *Zocalo* says a great deal about the city and its people: it presents a sense of daily regimentation, and evokes a day and an urban life punctuated by religion, state ritual and commerce.

Many of the works discussed in this essay exemplify a type of film-making which begins as non-narrative before becoming progressively akin to documentary. Indeed, what marks these works more than anything is their relationship with documentary and, in the extreme, surveillance. Many of the works find themselves located in the documentary-style, but several also begin to exist in what might be termed 'surveillance-style' — a form of film-making that takes into account a world in which observational films of infinite duration are in constant production. Several of the films discussed here depend on our ability to hold them in the mind long after they have been viewed. This conveyance of a specific rhythm of time, as linked to a certain place, registers itself on our psyche and carries with it a great deal of information. Seemingly, our experience of time can differ between places as dictated by the economic and social conditions at play. What takes us beyond conventional surveillance in the work of these artists is that they have in each instance brought a specific time and place to our attention for reasons relating to their own concerns. They are primarily engaging with a form of critical surveillance that tells the time of a place, and via the screen, relays how, simultaneously, that particular time shapes the place. Stepping back from these contemporary works, one can still sense how surveillance-style imagery melds time and place even in the work of the Lumière Brothers whose flickering films of factory workers and trains now play out on the Internet.

1 André Bazin, *Que-est-ce que
le Cinéma*, 1958–1965, Paris 1975.

2 John Grierson in Forsyth Hardy
(ed.), *Grierson on Documentary*,
London 1966, p.13.

3 Diedrich Diedrichsen, *Jeroen
de Rijke and Willem De Rooij*, exh.
cat., Van Abbe Museum, Eindhoven;
Villa Arson, Nice 2003.

4 In *Anri Sala*, exh. cat.,
Kunsthalle Wien, Vienna 2003, p.95.

5 Extracts from a conversation
notated verbatim by
Gerard Malanga during the filming
of *Empire. Andy Warhol Films, Art
and Superstars*,
www.warholstars.org/index.html

6 Bruce Nauman in an interview
with Michael Auping, in Janet
Kraynak (ed.), *Please Pay Attention
Please: Bruce Nauman's Words,
Writings, and Interviews*, Cambridge,
Mass. 2003, p.399.

7 Fiona Tan, *akte 1*, exh. cat.,
De Pont Foundation for Contemporary
Art, Tilburg 2003, p.51.

8 In Charles Esche,
'Yael Bartana', *CREAM 3*, London
2003, pp.56–9.

9 Bojan Sarcevic in an interview
with Antonella Berruti, April 2002,
www.pinksummer.com

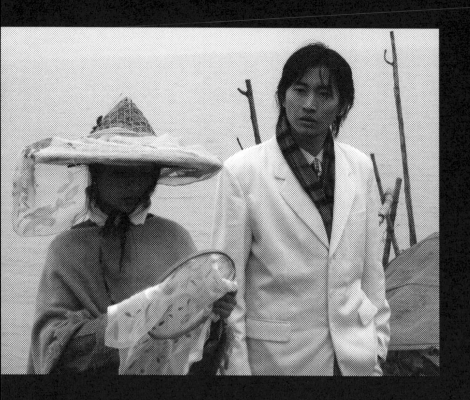

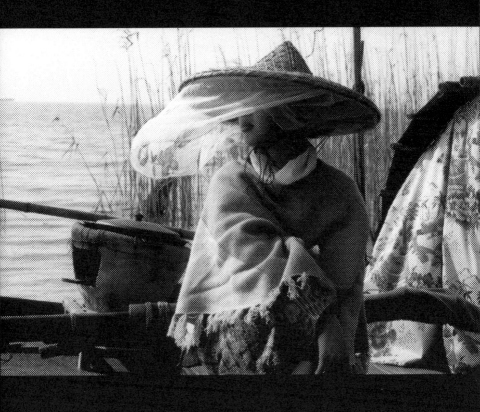

Yang Fudong *Liu Lan* 2003

Sylviane Agacinski

THE WESTERN HOUR

Is it ever possible to think about one's own time? The present emerges amid the shadows of a past that no longer evokes nostalgia and an uncertain future. A glance at neither the past nor the future can reveal the meaning of the present. We endlessly repeat the question of time as if it only just appeared in all its force since the retreat of what softened its tragic aspect: eternity and a sense of history. Against the background of this retreat, history reveals its contingency and our naked relationship to passage. Can the idea of epoch still hold meaning for us?

An Invisible Present

In Western History, epochs have been conceived as very large 'slices' of time corresponding to *worlds*, each presenting a certain unity, like antiquity or the Middle Ages. Hegel still divides world history into *worlds* — Oriental, Greek, Roman, Germanic — that are so many stages (*Stufengang*) in the history of Reason. These worlds not only succeed one another and advance through time, but they are also organized geographically from east to west.[1]

The events (like the French Revolution) meant to usher in new times are themselves conditioned by an invisible maturation and the slow death throes of the preceding period. Thus the ancient world gradually collapsed before the Christian world was established. According to Hegel's lovely formulation

'the continuous crumbling that has not altered the look of things at all is suddenly interrupted by the rising of the sun, which, in a flash, designs with one stroke the shape of the new world.' [2]

Without reviewing the Hegelian understanding of the idea of universal history — the most powerful yet to be conceived — let us remember that the teleological rationality that reconciles reason with time is fully realized there.

Hegel warned his audience: philosophical thought 'has no goal other than to eliminate chance.' [3] There is no true place, then, for *contingency* in human affairs. The final end of the world gives meaning to this history of which men themselves are not yet conscious but toward which they advance. Beginning with the Christian conception of history, the 'epochs' appeared as stages within an overall progression, as steps that humanity had to mount in order to rise toward the good and its true end. But the teleological principle according to which the world's progress would achieve one final goal (its *telos*), whether presented from a religious or a metaphysical perspective, has worn thin, giving way to, taken as a whole, a more or less random and disorientated history.

The idea of epoch is linked to that of world, just as time is inseparable from space. The hypothesis of a time that is ours — that is, the time of this world — presents itself as soon as we say *we*, as soon as we evoke a community of a 'generation' with that plural subject. We want very much to see this world's face and to define its contours. But only images, not the ambient world in which we live, have *borders*. The reality of the present is as impossible to *frame* as are the contours of a place through ordinary means of perception. It is the historian's job to hold up the mirror afterward to reflect the face of an epoch that its contemporaries could not perceive.

Religions, states, and empires have nevertheless defined the principal historical frameworks that allow us to demarcate extended epochs, worlds and civilizations. Traditionally, religion and politics have constituted the two orders in relation to which time could be divided and calculated. They had their defining events, such as the coming of a prophet or a god, the birth of a dynasty, the conquest of an empire. History was religious and political, and 'time' was too. But history has ceased to be organized by these two great forces.

Since the nineteenth century, the world's technical development has constituted the primary referential field for describing and organizing the whole of human societies. Henceforth, technical advances alone will determine the hierarchy of societies, which, by means of the global establishment of that same imperative for development, are integrated into a world and

a unique time. Globalization is the unification of the world's rhythms, all adjusted to the Western clock, that is, to contemporary chronotechnology.

In all domains, it is the technical order that provides the fundamental standards for classifying societies, as if in the final analysis, Western rationality had dominated all other worlds of thought — as in the Middle Ages when the time of the markets gained precedence over the time of the church.[4]

Through the techniques by which time is measured and through its assimilation as a market value, we can witness the Western hour's hold over the entire world. Enfolded in our time, distinct and distant societies are now inscribed into our own history. The technical hegemony of the West expresses itself all over the world through the extension of production methods and the establishment of its temporal architecture. But it is not only the measure of time that has been unified; it is also its value, reduced to the market value of work time. Western rationality has deployed an economics according to which time must be productive, useful, and profitable. We must forever 'gain time', because time itself gains us something else. That is why *to give* our time, to spend it or lose it, to let it pass, are now the only ways of resisting the general economy of time.

The economy is no longer only characteristic of Western societies; it has taken over the planet. Even though we move about more and more, it is nearly as difficult to travel in space (that is, to change our surroundings, to be displaced) as it is to change time or rhythm. For Lévi-Strauss, anthropology could still fall back on a 'displacement' technique and demand that we not apply our categories to so-called primitive societies (that is, societies without writing). Our gaze on societies *distant in space* was not supposed to reduce those societies to being *distant in time*, as in the old ethnocentric and historicist manner, which interpreted any gap as a delay. Differentialist anthropology thus renounced an evolutionist vision, marked by colonialist ambitions, that saw remote societies as *backward* societies, destined to catch up with *us*.

Nevertheless, even if the criticism of ethnocentrism has lost none of its theoretical relevance, we refer less and less to the close and distant in space or to any lags in time. As a planetwide technological empire, globalization has brought together the regions of the world and made its societies into contemporaries.[5]

'Primitive' societies have disappeared or are confined to museum-like reserves where they gradually lose their culture. The imperative for development, imposed on all continents, is absolute, so that it takes the form of an almost unquestioned shared ethic. And because it is both *universal* and

unequal, technological development has become the measure of all societies. Military and industrial power is adopted as a goal everywhere, and it is no longer possible for a Westerner to be *displaced.* Everywhere he finds himself at home, with the same religion of technological development, the same logic of profit, the same economics of time, and even the same 'local crafts', factory made and sold to tourists in all countries. Ethnocentrism has disappeared because it has been realized.

All countries are subject to the same logic, whether they are called *developing* (to avoid a 'politically incorrect' expression), *underdeveloped,* or *emerging* (if they are a bit more 'advanced'). But just as medications often bring with them 'undesirable' side effects, enthusiasm for the logic of power, associated with the craze for profit, leads to all sorts of perverse effects: the destruction of ecological, economic, or social stability. Pollution, unemployment, migration, and the breakdown of societies are some of the consequences of 'technological progress', which must henceforth be distinguished from mere 'progress' itself.

Slow Down History?
It has become difficult for us, therefore, to believe in a rational evolution of the world. Progress seems neither universal nor certain to us. This suspicion could change our conception of time and ward off our impatience: to what are we endlessly hurrying, so eager for change? And at the height of the movement that pushes us forward, what if the need to *temporize* were to become apparent? Quietly — it is true — imperceptibly, we await the future less, and it can be tempting to slow down history.

Lévi-Strauss's intelligent analyses can help guide us here to the extent that they have shown how the value given to change varies according to society. Just as our Western societies seem *made for change* — because they believe in the possibility of indefinitely increasing their knowledge and their power — likewise so-called primitive societies have only one goal, *enduring* and maintaining an equilibrium between humans and between humans and nature.

The division between 'hot' and 'cold' societies could make us consider the difference, always cropping up in our societies, between the 'progressives' and the 'conservatives' — which does not mean, as Marc Augé rightly pointed out, between the left and the right.[6]

This is because the conservatives are not always and not only on the right, and those devoted to progress or modernization can defend interests that are not at all 'leftist'. From a social or cultural perspective, this or that

advance is sometimes paid for by losses more serious than the gains. Thus, resisting the social effects of economic liberalism can make the left appear 'conservative' in a new sense.

No political thinking in our cultures is, however, 'conservative' in the sense that traditional societies could be. We cannot imagine ourselves removed from history, that is, from events that, even without progress, irreversibly transform the world and create the possibility for something new. For us, time remains *one way*, even if we do not know where that way is leading. Conversely, societies that 'refuse to accept history', in Lévi-Strauss's words, are those that live with reference to a mythic order that is itself *outside time*. Resistant to novelty, primitive 'conservatism' is driven by a concern for maintaining balances, especially the balance between the human and the natural worlds — an idea long foreign to modern Western thinking, except among the ancient Greeks.

If reference to an extratemporal order has become foreign to us, the need for maintaining balances or harmony is once again becoming clear through that modern concern for *conservation* that has nothing to do with the old political conservatism, but with worries about what must be *preserved*, what deserves to endure, as much as what must change. The valorization of protection expresses itself through the valorization of our cultural or natural heritage, the environment, or in the 'precautionary principle'. It has become legitimate to wonder about history and how it has accelerated, to want to check certain movements if the drawbacks of the new are often more serious than its advantages. When progress reveals itself to be the 'wheel with double gears' that 'make something go by crushing something else', according to Victor Hugo, we cannot look away from those it neglects or the values it destroys.

After having conquered the planet and imposed its technoeconomic imperative throughout, the West now harbors a need to resist the unconditional ideal of change, or 'progress', that breaks with the forward flight of yesterday's modernism and avant-garde ideas.

Nevertheless, this new relationship to time, reinforced by the memory of this century's disasters, is not tied up with any nostalgia and does not idealize the past. This is not a complaint against the technoscientific era or a hymn to the pastoral world of days gone by. Much invention is needed to safeguard what deserves to last, and technology can still correct its own faults — on the condition that it not be subjugated to the logic of profit alone. It is not the watches that impose the profitable use of time on the world; it is the impatience of the stock markets awaiting their profits.

We have no means of escaping temporality or history. But tested by an ephemeral world subject to dazzling metamorphoses, we recognize that time is an assistant to both good and evil. We can neither predict the future nor have faith in it, since in any case, things do not happen as we want. Thus it is necessary to 'navigate by sight', to agree to experiment with the short term and in limited areas. The certitude that no one can calculate tomorrow's global effects of decisions made today — even if attempts at such calculations are vital — is one of the reasons that we urge a slow-down of history. But is this possible and how? To the general economy of time, we would like to oppose the value of time itself, that is, of the time we agree to spend, to let pass, to lose.

Each generation is called on anew to experience the test of time. But what does *to pass* mean for us if neither eternity nor history any longer gives meaning to that passage? The vertiginous effect of the world's irreversibility is mitigated only by the possibility of enduring, which is the fruit of repetition and reproduction.

In the contemporary world, technology is expanding the possibility of repetition in an unprecedented fashion, and nature offers the models for it. Beyond the economic consequences of industrial means for reproducing certain merchandise in great quantities, the possibility of producing and multiplying images offers one of the strangest forms of repetition. Our world, overpopulated by images, makes us live among crowds of phantoms and doubt the homogeneity of our times.

Extract taken from Sylviane Agacinski, *Time Passing: Modernity and Nostalgia*, trans. Jody Gladding, New York 2003, pp.2–10.

1 See especially Georg Wilhelm Friedrich Hegel, *La Raison dans l'histoire*, Paris 1965, p.280.

2 Georg Wilhelm Friedrich Hegel, *Phénoménologie de l'esprit*, Paris 1947, p.12.

3 Hegel 1965, p.48.

4 See the essay by Jacques Le Goff, 'Au Moyen age, temps de l'église et temps du marchand' in *Pour un autre Moyen Age*, Paris 1977, pp.46ff. Republished in the 'Quarto' collection, 1999.

5 See Marc Augé, *Pour une anthropologie des modes contemporains*, Paris 1994.

6 Ibid.

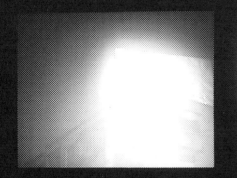

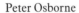

Peter Osborne

DISTRACTED RECEPTION:
TIME, ART AND TECHNOLOGY

The sort of distraction that is provided by art represents a
covert measure of the extent to which it has become possible
to perform new tasks of apperception ... *Reception in distraction
... [is] the sort of reception which is increasingly noticeable in all
areas of art and is a symptom of profound changes in apperception.*

— Walter Benjamin, 1936 [1]

Art distracts and art is received in distraction. For Walter Benjamin,
writing in the 1930s, it was architecture that had historically offered the
prototype of an artwork that is 'received in a state of distraction', but he
took the contemporary 'training ground' of distracted reception to be film.
Or rather, he took it to be cinema — a particular architectural space and
social use of the temporal qualities of film.[2] By the 1960s the cultural
training ground of distracted reception had changed location, from cinema
to television. Commercial cinema remained a distraction, but as a routi-
nised narrative spectacle that absorbed the viewer, it set few new tasks of

apperception, leading to a revival of that 'ancient lament that the masses seek distraction', from which Benjamin had distanced himself so decisively.[3] Today, with the digitally-based convergence of audio-visual communication technologies, the training ground of distracted reception has moved again, from television to the multiplying sites and social functions of the interactive computer-display screen. We are experiencing a new, more spatially diffuse 'cult of distraction' of the Internet, the economic — but not yet the artistic — significance of which is clear.[4]

In today's context of a renewed — and newly historical — interest in film and video in art spaces, 'the sort of distraction provided by art', and 'the new tasks of apperception' to which it attests, are at issue once more. As the economic logic of the cultural industries imposes itself on art institutions, subsuming them into its cycles of reproduction (as the research and development sector of advertising and design), the question of what modes of attention and experience are specific to art, at any particular historical moment, finds itself enlivened once again by technology. Technologies that were once artistically avant-garde (like video) are now commonplace, while the obsolescent commonplaces of the recent past (such as 16mm film) are being artistically revived by a backward-looking avant-garde in search of more opaque, less immediately received, artistic materials. It is nearly forty years since Yoko Ono first used closed-circuit video to introduce a real-time live image into gallery space — in *Sky TV* (1966), a camera on the roof transmits live images of the sky to the TV monitor in the gallery below. Today such imaging is ubiquitous. Meanwhile, Matthew Barney's *Cremaster* series uses both the production techniques and certain forms of 1960s and 70s commercial film; and younger artists self-consciously mimic the (in)formal film techniques characteristically used by conceptual artists in the 1960s. This has less to do with any 'revolutionary energy of the outmoded', than with a more general experimental rearticulation and refunctioning of technologies of perception and patterns of artistic and social use.

It is over one hundred and twenty years since 'attention' was first thematised as a psychological object and social problem — as part of a wide-ranging institutional construction of a new ideal type of subjectivity, appropriate to new forms of labour, education and consumption. As such, the history of attention is coterminous with that of both experimental psychology and aesthetics, as an empirical, rather than a philosophical discipline. Indeed, it is possible to view modernity itself as, in Jonathan Crary's words:

an ongoing crisis of attentiveness, in which the changing configurations of capitalism continually push attention and distraction to new limits and thresholds, with an endless sequence of new products, sources of stimulation, and streams of information, and then respond with new methods of managing and regulating perception.[5]

In this respect, attention is a norm produced by the fear of distraction, while distraction is a side-effect of attempts to produce attentiveness. This side-effect may be the negative result of a failure to produce attentiveness, or it may be a positive condition, reactively provoked by an attempt. Indeed, all attempts to produce attentiveness generate further demands to discipline, rechannel or otherwise deal with the distractions to which they themselves give rise. The double meaning of the German word *Zersteuung* is exemplary in catching the ambiguity of this process, since it can refer to both the psychological phenomenon of the dispersion or scattering of perception and the principal social object of diverted attention: entertainment.[6] Art has a distinctive role in this process, not merely as a 'measure' of our capacity to perform new tasks of apperception, combining attention and distraction in complex ways, but, critically, as a site of reflection upon their meanings and possibilities — the object of a 'distracted examination'.[7]

Art distracts and art is received in distraction. This is as true of art in gallery-space as it was of early cinema. The ideology of 'contemplative immersion' in, or 'absorption' by, the artwork continues to regulate its reception, but distraction is deeply implicated in the demand for this special kind of attention. We go to the gallery, in part, to be distracted from the cares and worries of the world. To be so distracted, we must attend to the artworks on display. Yet, once there, the kind of attention demanded by the works (and by the institutional context) — contemplative immersion — can produce an anxiety that itself generates a need for distractions. This need develops either because the work does not seem able to sustain such attention, or, perhaps, because of the disciplinary character of the demand itself. This need for distraction is readily fulfilled by the gallery: by the sounds and movements and sight of other viewers, by the beguiling architecture of gallery-space, the view out the window, the curatorial information cards, the attendants, and by other works. (Perhaps this is the function of grouping works together in the same visual space: they provide a psychic space of distraction which eases the anxiety involved in giving oneself up to a

particular work. Other works 'gaze' at the viewer behind his or her back, making their own claims on his or her time, providing the reassurance of possible distraction.)

Art is received with an attention invested with an anxiety about distraction: both distraction from the work and the 'distraction from distraction' that is attention to the work. Here, attention *is* distraction (from distraction); distraction is attention (to other objects). Their dialectic generates an embodied, non-perspectival, baroque space of distraction.[8] But if what art must distract its viewers from — in order to function critically as art — is not just the cares and worries of the world but, increasingly, distraction (entertainment) itself, how to distract from distraction without simply reproducing it? How is art to be received in distraction without becoming simply another distraction? Alternatively, how is art to distract from distraction without losing touch with distraction, without entering another realm altogether — contemplative immersion — with no relation to other distractions, and thereby becoming the vehicle of a flight from actuality, from the very temporal structure of experience which it must engage if it is to be 'contemporary' and effective?

These are issues with which modernist and avant-garde art has grappled since the 1940s. They are raised especially sharply by the temporal aspects of recent uses of film and video in art spaces. For the dialectic of attention and distraction is a dialectics of duration. This is a dialectics of continuity and interruption, of rhythm. As such, it is a particular inflection of the process of temporalisation — the production of time — itself. Film and video works in art spaces intervene into this temporal dialectic, syncopating the time of the viewer into new rhythms and forms.

Duration

Since the later part of the nineteenth century, post-Kantian European philosophy — the metaphysical and phenomenological alternative to the reductively 'analytical' side of the modern philosophical tradition — has been first and foremost a philosophy of time. From Bergson, Whitehead and Husserl, via Lukcàs, Heidegger and Benjamin, to Levinas, Ricoeur and Deleuze, European philosophy opposed the reification or hypostasisation of 'being' in traditional metaphysics with a series of meditations on time. This turn to time as *the* philosophical topic was largely based on reflections upon the distinctive features and implications of 'subjective' time: in particular, Bergson's duration, Husserl's absolute flow of consciousness, and

Heidegger's existential 'temporalisation'. In this respect, the establishment of the priority of time over being in twentieth-century European philosophy consummated the triumph of the principle of subjectivity in Western thought. Yet, in the very same act, it threw into doubt the boundaries and the identity of the subject, dissolving it into, or fracturing it by, time.[9] Similarly, in the dialectic of attention and distraction, the subject finds itself temporally as well as spatially dispersed, distributed across its relations to different objects of perception by different architectures and technologies of time.

Film is, famously, the technology of representation most closely associated with philosophical insight into the mutual and paradoxical constitution of time and the self. For Benjamin, it was the medium in relation to which 'all problems of contemporary art find their definitive formulation'; just as, today, it is in relation to audio-visual digital technologies that the problems of contemporary art need to be rethought.[10] Viewed through the prism of film and its successors, the metaphysical meaning of contemporary art appears in its articulations of time and subjectivity. The rich field of the modern philosophy of time thus becomes a mine of conceptual resources for the philosophical interpretation of contemporary art. Foremost among the concepts that it offers is that of duration.

In its most general sense, 'duration' names that form of temporal continuity — the experience of being in time — by which time is distinguished from space. It is usually taken to have achieved its first philosophical elaboration in St Augustine's notion of an expanded, 'threefold' present: the coincident consciousness of the past, the present and the future, in memory, attention and expectation, respectively. As a temporal totality — there is nothing in time outside this present — the expanded present is not point-like (the instant), but endures. It endures dynamically as a constant movement between its constituent parts, as what was present to attention becomes memory, as new objects of attention are realised, as new expectations arise and so on.[11] However, the French philosopher Henri Bergson, with whom the concept of duration is primarily associated, sought to render duration absolute. He argued for the complete separation of time from its conceptual dependence on being represented in spatial terms. (The familiar idea of time as a succession of instants, for example, depends upon representing it spatially, as a line. And the Augustinian notion of an 'expanded' present remains dependent upon this spatial analogy.)

According to Bergson in his *Essay on the Immediate Data of Consciousness* (1889), 'time conceived under the form of a homogeneous medium, is some spurious concept, due to the trespassing of the idea of space upon the field of pure consciousness.' It is 'nothing but the ghost of space haunting the reflective consciousness.' Pure duration, on the other hand, is 'succession without distinction'. It is pure *qualitative* differentiation, without quantitative measure: 'the form which the succession of our conscious states assumes when our ego lets itself *live*, when it refrains from separating its present state from its former states.' This is a 'continuous or qualitative multiplicity with no resemblance to number.' It has as its image the unity of the notes of tune, which are not discrete to consciousness, but form a continuity by 'each permeating the other'. [12]

Bergson went on to elaborate this phenomenological metaphysics of time in relation to both matter (*Matter and Memory: Essay on the Relation of Body to Mind*, 1896) and evolution (*Creative Evolution*, 1907). Having pushed the dualism of mind and body (time and space) to an extreme, he claimed to have transcended it with a new philosophy of life based on a single dynamic impulse, the *élan vital*. Initially conceived as a psychological phenomenon, duration became the metaphysically real sphere of 'virtuality', from which (spatial) actuality is incessantly produced as a world of discrete beings and relations by the creative and transformative processes of life itself: 'duration means invention, the creation of forms, the continual elaboration of the absolutely new ... the organized body ... grows and changes without ceasing.' [13] Concrete durations are thus qualitative times specific to the life of different organisms, 'cut out' of the continuous flow of pure duration by the self-organisation of 'life'.

After a period at the beginning of the twentieth century in which this religious naturalism of the *élan vital* dominated French intellectual life, Bergson's philosophy fell rapidly into obscurity in the 1930s, from which it has been rescued only recently — and catapulted to the height of philosophical fashion — by Gilles Deleuze, largely on the basis of its affinity with cinema. [14] Bergson himself made this connection as early as 1907, when he referred to 'The Cinematographical Mechanism of Thought' in the title to chapter four of *Creative Evolution*. Despite its apparent historical distance from current debates, this connection (exploited by Deleuze to other ends) can help to clarify a decisive difference between cinema, on the one hand, and film and video in art spaces, on the other.

For Bergson's attempt to establish the metaphysical distinctiveness of time via its absolute independence from, and primacy over, space, is the philosophical correlate of the cinematic ideology of the de-realised image. This is an ideology of visual perception that functions by repressing the spatial conditions of viewing; just as cinema itself progressively 'blanked out' all distractions but the screen, in a populist mimicry of the contemplative immersion demanded of the viewer of art by aestheticism. The marked spatiality of the modes of display of film and video in art spaces, on the other hand, and crucially, the movement of the viewer through gallery space, undercuts the false absolutisation of time to which cinema is prone. Furthermore, it highlights the *constructed* — rather than received — character of temporal continuity.

Bergson treated 'pure duration' as an absolute continuity, from which the continuity of concrete durations derive. However, this treatment begs the question of how continuities within being (and especially psychic continuity) are possible, since they must be established in the face of — across and against — temporal discontinuity as the level of beings (in space), rather than within the virtuality of pure duration itself. For, as Bergson himself insisted, time is continuous only as virtuality, hence as 'nothingness'; never in being. Within being, there will therefore always be a *dialectical dependence of continuity upon discontinuity.* In Bachelard's words, 'psychic continuity is not given but made'. And it is made out of the temporal structure of the relations between acts: 'what has most duration is what is best at starting itself up all over again'. Duration is a dialectical process of continuity, interruption, and beginning again — always beginning again. The fundamental concept of time is thus not continuity (as Bergson thought), but temporalisation as rhythm. And the fundamental concept of a general rythmics is 'the restoration of form'. [15]

Time-based technologies of representation construct their own forms of temporal continuity out of their own technologically-specific temporal differentiations (24 frames-a-second, for example). And the temporality of reception will be a product of this temporality of the work and the other temporalities at play in the field of the viewer — temporalities that are embodied articulations of spatial relations. Each work makes its own time, in relation to its space, and hence to other times; but it can only succeed in doing so by taking into account in advance the spatio-temporal conditions — the dialectic of attention and distraction — characteristic of its prevailing reception. The work of art is in a deep sense 'contextual'. It necessarily incorporates some projected sense of its conditions of reception into the logic of its production.

It is through the spatial articulations of temporal relations that time is socialised. The temporal dialectic of distracted reception, into which art film and video intervene, is a socio-spatial, as well as a psychological, one. Indeed, when Benjamin wrote of reception 'in a state of distraction', he identified it with reception 'through the collective', that is, with a certain public use. [16] (Distraction, one might say, is the sociality of attention.) This raises the question of the character of the collectivity at work in the distracted reception of contemporary film and video art; and through it, the question of the broader, historical time within which it is inscribed and upon which it draws. There is a complex overlay of rhythms condensed into the casual act of viewing a work of art. One criterion of judgement of a work — one new task of apperception — might be the extent to which it opens up this network of temporal connections (psychic, social, historical) to a reflective and transfigurative view.

Large-scale, quasi-cinematic video installation, for example, is a staple of contemporary art. The sort of distraction it provides is in some respects not unlike that of early cinema, in that it acknowledges its spatial conditions as part of the viewing experience (albeit usually negatively, by enclosing itself off from the rest of the gallery). But the form of collectivity here is very far from that of the cinematic masses of Kracauer's picture palaces; it is a privatised, serial, small group affair. The work has only a short time to engage, and immobilise, the sampling viewer, by imposing its image and rhythm; although once captured the cinematic conditions of blackout will help to keep the viewer lingering, before they move off and out to the next distraction. This subsequent distraction might be a work displayed on a monitor, perhaps, standing previously ignored in a gallery corner. What this points to, I think, is a deepening of distracted perception; psychic attention in dispersal is not a barrier to, but more simply, a condition of reception.

At their best, contemporary galleries reproduce the antagonistic multiplicity of the social image-space in such a way as to impose new reflective rhythms of absorption and distraction, new articulations of duration, interruption, beginning, ending, repetition and delay. As Bourriard among others has argued, it is the exhibition, not the individual work, which is the basic unit of this experience.[17] The global informational metropolitan 'non-place' of the city is the exhibition's context; digital technologies are the basis of its operational techniques. And increasingly, philosophies of time hold the key to its interpretation.

1 Walter Benjamin, 'The Work of Art in the Age of its Technical Reproducibility (Third Version 1936-9)', in Howard Eilnad and Michael W. Jennings (eds.), *Selected Writings, Volume 4: 1938-1940*, Cambridge, Mass and London 2003, pp.268-9.

2 Benjamin 1936-9, pp.268-9. The first affirmative (as opposed to merely derogatory) cultural analysis of distraction was Siegfried Kracauer's 'Cult of Distraction: On Berlin's Picture Palaces' (1926), *The Mass Ornament: Weimar Essays*, trans. and ed. by Thomas Y. Levin, Cambridge, Mass. 1995, pp.323-8. The shows in Berlin cinemas, Kracauer argued, 'raise distraction to the level of culture' (p.324). The historically determined conflation of film with cinema in Benjamin's famous essay vitiates its contemporary relevance. As Anthony McCall has put it, one can 'quite easily imagine film as a medium disappearing quietly in the next ten years with scarcely a blip in terms of the practices of cinema.' 'Roundtable on the Projected Image in Contemporary Art', *October*, no.104, Spring 2003, p.74.

3 Benjamin 1936-9, p.268. Kracauer 1926, p.325: 'Self-pitying complaints about the turn to mass taste are belated.' The term 'apperception' is used within this discourse to refer to the self-awareness of the perceiving subject, in distinction from the object-oriented process of perception.

4 What is clear is that — whatever it turns out to be — its artistic significance will exceed the limited horizons of 'internet art' and involve a generalisation of certain formal operations across different media just as film provided a repertoire of formal techniques for all the arts.

5 Jonathan Crary, *Suspensions of Perception: Attention, Spectacle, and Modern Culture*, Cambridge, Mass. and London 1999, pp.2, 13-14, 29.

6 Crary 1999, pp.48-9; Howard Eiland, 'Reception in Distraction', *Boundary 2*, vol.30, no.1, Spring 2003, pp.51-66.

7 Benjamin 1936-9, p.269.

8 See Anthony Vidler, 'Dead End Street: Walter Benjamin and the Space of Distraction', *Warped Space: Art, Architecture, and Anxiety in Modern Culture*, Cambridge, Mass. and London 2000, pp.81-97.

9 The best critical account of this history (which has its beginning in Kant) is itself a major contribution to the tradition: Paul Ricoeur, *Time and Narrative*, 3 volumes (1983-5), trans. Kathleen McLaughlin and David Pellauer, Chicago 1984-8. More generally, for a selection of texts, see Charles M. Sherover (ed.), *The Human Experience of Time: The Development of its Philosophic Meaning*, Evanston 1975.

10 Walter Benjamin, *The Arcades Project*, trans. Howard Eiland and Kevin McLaughlin, Cambridge, Mass. and London 1999, p.394. Film, Benjamin writes, is the unfolding result of 'all the forms of perception, the tempos, the rhythms, which lie preformed in today's machines.'

11 St Augustine, *The Confessions*, Book 11, trans. R.S. Pine Coffin, New York 1961.

12 Henri Bergson, *Time and Free Will: An Essay on the Immediate Data of Consciousness* (1889), trans. F.L. Pogson, London 1910, pp.98–100, 105.

13 Henri Bergson, *Creative Evolution*, trans. Arthur Mitchell, New York 1911, reprinted New York 1998, pp.11, 14. More generally, see Keith Ansell Pearson, *Philosophy and the Adventure of the Virtual: Bergson and the Time of Life*, London and New York 2002.

14 Gilles Deleuze, *Cinema 1: The Movement-Image*, trans. Hugh Tomlinson and Barbara Hhabberjam, London 1986; *Cinema 2: The Time-Image*, trans. Hugh Tomlinson and Robert Galeta, London 1989. Deleuze's philosophical under-standing of Bergson was essentially complete as early as his 1956 essay, 'Bergson's Conception of Difference', in Gilles Deleuze, *Desert Islands and Other Texts, 1953–1974*, ed. David Lapoujade, trans. Michael Taormina, Los Angeles and New York 2004, pp.32–51.

15 Gaston Bachelard, *The Dialectic of Duration* (1936), trans. Mary McAllester Jones, Manchester 2000, pp.44, 19–20, 133.

16 Benjamin 1936–9, p.268.

17 Nicholas Bourriaud, *Relational Aesthetics*, Dijon 2002, p.72.

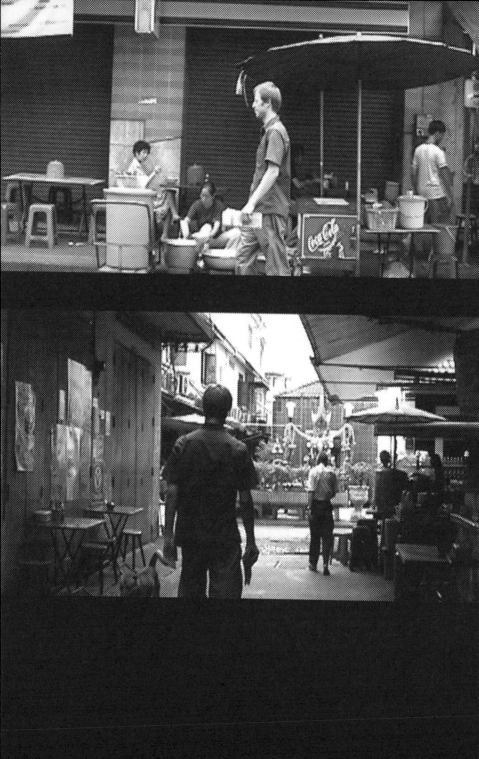

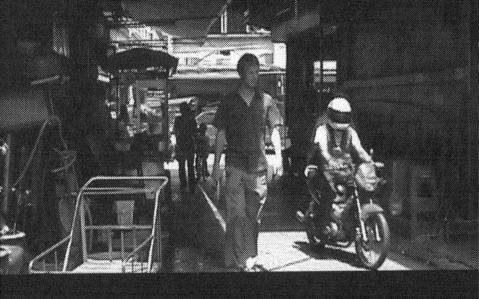

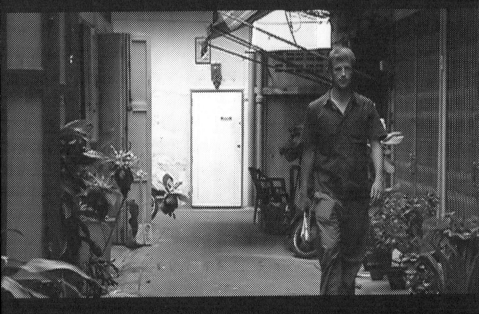

Bojan Sarcevic *Untitled (Bangkok)* 2002

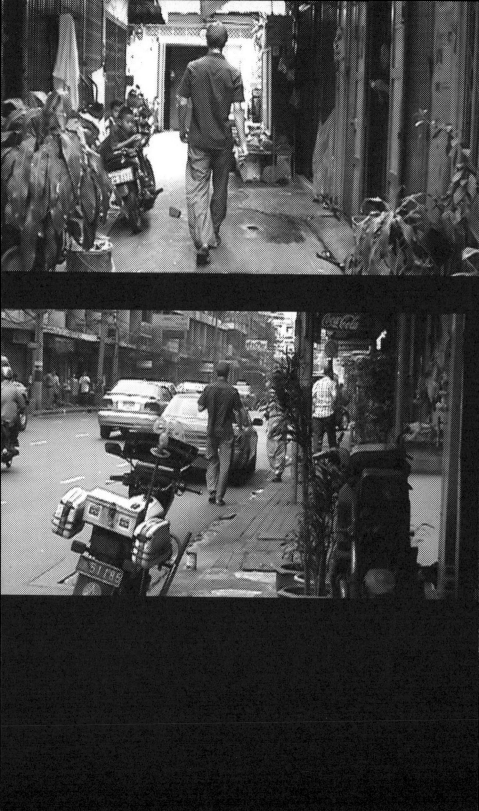

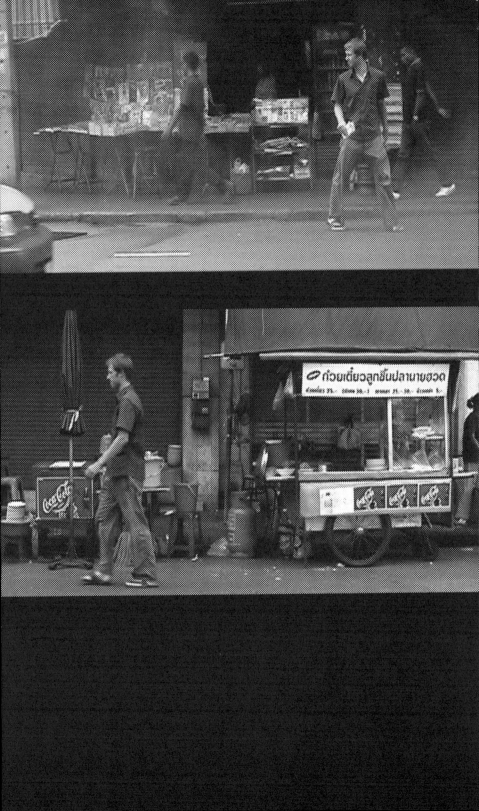

Wolfgang Staehle *Comburg* 2001

Irit Rogoff

THE WHERE
OF NOW

'But will it signify', she asked worriedly, *'Will it signify over there?'*

The question, asked within an art world context and relating to the signifying possibilities of some travelling artwork, suddenly seemed very dated. When, I wondered, had we stopped worrying about whether works from 'over there' might or might not be able to fully communicate themselves 'over here' or vice versa? When did we begin to assume a fluidity of circulating meanings in which not only is the signifier detached from the signified, but in which the *enunciative* had also taken over from the *interpretative*? When had such a shift occurred between meaning anchored in contexts and representational strategies, and the circular operations of singularities and cross-cultural translations?

Within the art world, in both curatorial and artistic practice, there has been an obvious movement towards a global, fluid form of circulation. At the same time, this circulation has not manifested a simple-minded claim that everything is in motion in relation to everything else. Instead, this shift suggests the existence of a process which complicates all of those old questions regarding local contexts, places and positions from which we speak.

Simultaneously with this seeming shift taking place in the precise articulation of *where* we speak from, we have also had experience of numerous

84

international exhibitions such as Documenta XI (2002), the Istanbul Biennale (2003) or Manifesta 5 (2004), to name only a prominent few, which have foregrounded an art practice that informs in a seemingly factual way, but at a slight remove from *reportage*. We could say that this shift indicates a move away from supplying various pieces of information about a *place* or a *site*, and instead suggests a tendency to play with our consciousness and toy with notions of a direct and uncomplicated experience of place. Here we can recognise an art practice that focuses our attention on something that we need to know but haven't the ability to see, the proximity and access to observe, or the cunning and wit to discern. An art practice that obliquely and poetically pulls together conjunctions and patterns that form the interlinked webs of commerce, circulation, mobility and belonging. And yet, these contemporary arts practices are not historically or materially specific as they were of old, for they do not rely on 'context' for their embedded meaning. Instead we have around us numerous works whose capacity for observation and for ferreting out all kinds of unexpected conjunctions of information is put towards the task of articulating newly imagined realities rather than towards describing the conditions of realities we have long been able to name and to label.

In the process, a concept of 'location' — a defined entity in relation to which we instantly know how to position ourselves — has greatly eroded. The 'where of now' of my title refers to the fact that location is increasingly a slippery construct of conjunctions between virtuality, materiality and the vicissitudes of circulating signs. In RAQS Media Collective's video, text and sound installation *A/S/L (Age/Sex/Location)* (2003), workers at a call-centre in India 'living between an online and an offline world in time zones on the outer reaches of cyberia' are taught to sound and be able to introduce references familiar to the inhabitants of the culture they are making calls to (on behalf of some multinational company employing data outsourcing). According to Ursula Biemann, *A/S/L* 'maps the time geography of shifting identities in a new economy, where call centre employees who are physically located in India answer customers in Minneapolis in a Midwestern accent.'[1] *A/S/L* confronts us with a slippery location which can only be understood temporally. Situated neither in India nor in the American Midwest, we find the production of a corporate location within a fibre-optics network which redefines many elements including the location of the work and the location of the communication. In this process of redefinition, the work confounds everyone's certainty that it is possible to know who you are talking to. The

new digital proletariat that operates these call-centres around the globe embodies the 'where of now', being simultaneously materially located and virtually dislocated. As such, this proletariat produces a performative alternative to the polarity of such opposites in earlier discourses, which often confused identifiable location with understanding. And that, of course, is the point: the Enlightenment legacy, so central to the constitution of geography as knowledge, holds that to be able to name and locate automatically leads to being able to know.

In contrast, many contemporary art works operate on producing somewhat oblique lines of identifying location. In Tate's 2004 exhibition *Time Zones*, much of the work displays an elusive and double-edged relation to the encoding and decoding of its geographical emplacement. In Anri Sala's *Blindfold* (pp.17, 63–5) the glistening vacant billboards holding all the promise of 'soon-to-be-available' globally circulating commodities co-exist on screen with lumbering workers and municipal buses, with soulless housing projects in Tirana and Velora redolent of an earlier Socialist vocabulary. Neither defining nor contradicting each other, these two vocabularies provide a double occupation that fractures synchronic time, the old time of history. Instead, as Eric Alliez says, 'A wild temporality characteristic of capitalism has historically effected subjectivity and the movement of thought.'[2] The 'wild temporality' in this case has to do with the fact that neither vocabulary has replaced one another in triumph of one so-called ideology replacing an earlier one. Instead they enact 'Examples of disjunctures produced by globalisation … media flows across national boundaries that produce images of well being that cannot be satisfied by national standards of living and consumer capabilities'.[3] Rather than factual knowledge, Sala's work produces a subjectivity that is split between contradictory signs and is accepting of it, not attributing it historically, ideologically or geographically. It is a subjectivity characterised not by any identifiable characteristics, properties or tropes of place but by what Giorgio Agamben has called 'whatever singularity':

> The coming community is whatever being … The Whatever in
> question here relates to singularity not in its indifference with
> respect to a common property (to a concept, for example; being
> red, being French, being Muslim) but only in its being such as it
> is. Singularity is thus freed from the false dilemma that obliges
> knowledge to choose between the ineffability of the individual
> and the intelligibility of the universal.[4]

Imaging the subjectivity of 'whatever singularity' does not involve digging for the truth behind the images, nor inventing new and more truthful visual tropes. Instead, this singularity involves evacuating old assumptions and mobilisations from extant images. In a previous formation there was a necessary alliance between identity ('being Red, being French, being Muslim') and the placing of that identity within a national, regional or cultural location (being Turkish, being Northern European, being of the art world). In the current moment, however, the mutual dependence of these two categories has been loosening in intriguing ways.

Location, Location, Location
It would seem that only in the hyperbolic speech of the property market is location still ascertainable with such simple clarity: determined in relation to value, and referencing a proximity to some notion of a 'centre'. Equally, only in the world of privately owned property and urban development and gentrification, can place and location be defined by boundaries that allow it to neighbour simultaneously and separately both less and more desirable areas and to confer identity by proxy.

In all other aspects of our lives we have long abandoned notions of clear, coherent and located identities. The trials and tribulations of identities on the move are testing the limits of containment enacted by national boundaries. Instead of bureaucratically regulated divisions, we have the constitution of extra-territorial spaces for the containment of 'illegal immigrants' such as camps and centres for refugees and asylum seekers. These and other formations are made up of the entanglements and mixings of vast populations of those who inhabit the grey zones of unsanctioned but necessary labour in reluctant host cultures.

'Where do I belong?' seems to be the question that plagues so many of the discussions I participate in. As a constant lament it refers to dislocations felt by displaced subjects towards disrupted histories and to shifting and transient national identities. Equally, it refers to university departments and orders of knowledge, to exhibiting institutions and market places and, not least, to the ability to live out complex and reflexive identities which acknowledge language, knowledge, gender and race as modes of self-positioning.

'Where do I belong?' It is one of those misguided questions that nevertheless serves a useful purpose, for while it may naively assume that there might conceivably be some coherent site of absolute belonging, it also floats the constant presence of a politics of location in the making. This very act

of constant and plaintive articulation serves to alert us to the processes by which identity comes into being and is permanently in flux. As a quest(ion), it brings to mind a lovely sentence from Salman Rushdie's 'Outside the Whale', in which he advocates taking issue with George Orwell's assumption that there is an inside in which to be passively swallowed up: 'In place of Jonah's womb, I am recommending the ancient tradition of making as big a fuss, as noisy a complaint about the world as is humanly possible. Where Orwell wished quietism, let there be rowdyism; in place of the Whale, the protesting wail'.[5] Therefore the positioned location I am examining, so totally outside the whale, is the geography of keening and wailing, of location as a form of criticality, of trying to find both articulation and signification for that constant unease between efforts at self-positioning and the languages and knowledge available for us to write these into culture. It is an unease inscribed with both a sense of loss of that earlier seamless emplacement we might have thought we had, as well as with the insecurity of not yet having a coherent alternative to inhabit.

Location, then, is by definition the site of performativity and of criticality rather than a set of naturalised relations between subjects and places. How, within this shift, can we address issues of a necessary and critical cultural location? How can we perceive the place from which we speak, in which we ground our positionality, from which we understand meaning, and in which we might be able to foresee an effect? How, in short, can we begin the task of understanding 'the Where of Now' as another formation of location, the location of singularity rather than of specificity.

Critical Singularities

I take up these questions and these observations in the footsteps of Jean-Luc Nancy's recent and exciting work in *Being Singular Plural*, a body of thought that has done much to enable us to detach 'singularity' from individuality and the politics of autonomous selves.[6] Although Nancy's starting point is quite different from the one being rehearsed here — he is not concerned with rewriting the notion of location for contemporary arts practices but rather with taking up a twentieth-century philosophical discussion of 'being', Nancy argues for a modern interpretative process of what Plato had called the 'dialogue of the soul with itself'. In his argument, Nancy breaks down the 'with' of 'with itself' to another, less inward, more plural set of links. He is doing so in the name of a complex and very contemporary politics which he produces as an almost syncopated litany of what he calls:

places, groups, or authorities (... Bosnia-Herzegovina, Chechnya,
Rwanda, Bosnian Serbs, Tutsis, Hutus, Tamil Tigers, Krajina
Serbs, Casamance, Chiapas, Islamic Jihad, Bangladesh, The Secret
Army for the Liberation of Armenia ... ETA Militia, Kurds
(UPK/PDK), Montataire, The Movement of Self-determination
... Roma gypsies of Slovenia ...) that constitute the theatre
of bloody conflicts among identities, as well as what is at stake in
these conflicts. These days it is not always possible to say with
any assurance whether these identities are international,
infranational, or transnational; whether they are 'cultural',
'religious', 'ethnic', or 'historical': whether they are legitimate or
not — not to mention the question about which law would
provide such legitimation: whether they are real, mythical, or
imaginary; whether they are independent or 'instrumentalised'
by other groups who wield political, economic, and ideological
power ... This is the 'earth' we are supposed to 'inhabit' today.

In the work of Serbian artist Milica Tomic, her own body bears the marks of
these split identifications and awkward relations to place. In a photographic
billboard produced for the Vienna Secession (2000) the artist is dressed in
a military uniform reminiscent of the Partisan armies of the Second World
War. Next to her is her colleague Roza El-Hassan, wearing something very
Western and fashionable. Both are being driven around in a Porsche by an
affluent and hapless looking Austrian. The text next to the photograph states:
'Milica Tomic and Roza El-Hassan driving in the Porsche and thinking about
over-population'. The women embody the recent conflict in the Balkans and
the benign and puzzled incomprehension with which the auto-destruction
of Yugoslavia was greeted by its Western neighbours. Looking like cheerful
and delighted tourists they bear the internal contradictions of their tortured
location with an ease that does much to complicate the simple-minded binary
classification of ethnic politics that was the media's characterisation of that
political conflict. Similarly, in the film 'I am Milica Tomic', the serene and
beautiful artist wears a white evening gown and circles in front of the camera,
uttering her own name and a different country of origin in a different lan-
guage, at each turn. As she rotates, her body becomes covered with bloody cuts,
the embodied price of this enforced linkage between a proper name and its
supposedly coherent identity.[7] Like the articulation of Nancy's list, Tomic
performs singularity and has a relation to place but not one of identity or

belonging. Tomic enacts the impossibility of simple relations as well as their replacement by oblique conjunctions. She inhabits that 'wild temporality' in which the tortured legacies of Second World War partisan histories and of later ethnic hybridities ride around in a convertible with the comfortable circumstances of Western European prosperity, and everyone smiles.

Earlier, I quoted Nancy at such length because of the litany of names and places he puts forward, stressing the importance of the act of listing them and the burden of trying to understand their contradictory logic. Not only do these lists of emergent distinctions inhabiting the same terrain constitute the 'theatre of bloody conflicts among identities', Nancy claims, but they also constitute a counter-logic to named location. The lists endow the blander discourses of globalisation (ones which have been trying to problematise the vision of a world fundamentally characterised by objects in motion) with a truly dramatic effect.

> To say that globalisation is somehow about things in motion
> somewhat understates the point. The various flows we see —
> of objects, persons, images, and discourses — are not coeval,
> convergent, isomorphic or spatially consistent. They have
> what I have elsewhere called relations of disjuncture. By this I
> mean that the paths or vectors taken by these kinds of things
> have different speeds, axes, points of origin and termination and
> varied relationships to institutional structures in different
> regions, nations, or societies. [8]

I want to take up the notion of 'singularity' in relation to place, location and globalisation because it seems to enable the kind of fractured conjunction that Tomic's images and Nancy's parade of unacknowledged identities manage to produce, at times in a comic, and at times in a tragic, vein. 'Singularity' is being that is not inscribed with identity, that is not legibly related to other beings but nevertheless performs some form of collectivity or mutuality.

It is possible to juxtapose the grounded specificity of conventional geographical locations with the emergent logic of singularity. While the specific is true to a logic of its contexts, the singular is true to a logic of its own internal self-organisation. According to Peter Hallward in *Absolutely Postcolonial*:

> The singular and the specific ... divide most obviously,
> most naively, in their tolerance of positioned interests

and 'worldliness' in the most general sense. According to the
singular-immediate logic, in order to grasp the truth of the
created world, you first have to step outside of it ... The specific
on the other hand implies a situation, a past, an intelligibility
constrained by inherited conditions ... Within the world,
the specific relates subject to subject and subject to other; the
singular dissolves both in one beyond-subject. [9]

In Francis Alÿs's *Zocalo* (pp.12–13), a flag-pole located in a central square
in Mexico City marks the process of an endless spatial sub-division of the
square itself. People finding shade in its shadow, including those participat-
ing in arbitrary and inexplicit military formations and ad hoc festivities, as
well as hawkers and idlers, continuously rewrite what is generally perceived
as a space of exemplary civic pride. They challenge the nature of urban pub-
lic space, converting it into a ramshackle unfolding of numerous mundane
moments. The long duration of the piece, the continuous spatial habitations
that flow one into the other, and the flat light that illuminates its sprawling
surface, work to refuse a translation from one urban myth — that of archi-
tectural and civic achievement — into another urban myth, that of a chaotic
crowd whose urban roamings follow a seemingly incomprehensible logic.
(This second myth is so very prevalent in the accounts of other modernities.)
Alÿs has managed to take a named location and dissolve it into '*one beyond
subject*', unframing it from any attempt at local characterisation. Viewing
from high above the square, the artist eschews an organising gaze 'under
whose reign everything can be taken in by a single glance from the mental
eye which illuminates whatever it contemplates'. [10] Instead, people come and
go, inhabiting the space for a moment or two, inhabiting it through *duration*
rather than through the identity they are assumed to represent.

Double Horizons
To evolve the vocabulary we need in order to establish a temporal subjectiv-
ity within a global circulation we might follow Homi Bhabha towards the
'double horizon' in which temporality and spatiality goad one another into a
different set of political and cultural relations.

It was through my interest in the 'intermediary life' of
the global experience ... that 'Third Space' somewhere between
the old and the new — that I became aware of a kind

of contiguous, double horizon that hovered over the global discourse. It was a shuttling back and forth between continuity and contiguity the tension of the 'New World Order' surviving in the dogged persistence of the 'National' and the fragile future of the Trans National/International Civil Society.[11]

It would be so simple to refer to 'globalisation' (as everyone around us seems to do all the time), for some schema of the movement of everything in relation to everything else. But it seems that on the whole, globalisation is juxtaposed with location or locality in the binary structure of negative differentiation in which the one intimates an explicit 'somewhere' while the other intimates a 'nowhere' or 'everywhere'. As Arjun Appadurai has written:

It has now become something of a truism that we live in a world characterised by objects in motion. These objects include ideas and ideologies, people and goods, images and messages, technologies and techniques ... It is also a world of structures, organisations and other stable social forms. But the apparent stabilities that we see, are under close examination, usually our devices for handling objects characterised by motion.[12]

As Appadurai rightly states, the nation-state which occupies the claim to stability proves to be as much 'in motion' as the forces of globalisation which are deemed to counter it. This motion can be usefully taken up when the fixity of 'place' as bounded, internally defined and named, is suspended and replaced with a different understanding of location as fluent conjunctions of space and time. In this case, space and time are related to one another through that 'double horizon' of continuity and contiguity that Bhabha speaks of.

In contemporary arts practices we have recently seen the rise of works that explore and investigate the course of oceans, rivers and waterways, as well as of cargo, shipping, leisure and migration across bodies of water, and of the lives of ships that glide through them or sink to their bottoms. Michel Foucault famously declared :

The boat is a floating piece of space, a place without a place, that exists by itself, that is closed in on itself and at the same time is given over to the infinity of the sea and that from port to port, from tack to tack, from brothel to brothel, it goes as far as the colonies in

search of the most precious treasures they conceal in their gardens,
you will understand why the boat has not only been for our
civilisation ... the greatest instrument of economic development ...
but has been simultaneously the greatest reserve of the
imagination. The ship is the heterotopia *par excellence*. [13]

Considering works such as Allan Sekula's *Fish Story* (1995), Multiplicity's
Solid Sea (2002) and *The World* (2002) (set on a floating residential ship),
Laura Horelli's *Untitled* (2004), about work on cruise ships, or Matthew
Buckingham's new world elegy on the Hudson River (2004), we once again
glean the 'wild temporality' coined by Alliez. [14] All of these works lay out
great swathes of previously unconnected spheres: ports, cargos and longshore-
men; shipyards, engineers and the leisure cruise industry; illegal ship-based
immigration attempts that end in tragedy and the intricate state bureaucra-
cies that deny their ever having existed.

But beyond the detailed explorations of how all of these watery sur-
faces and economies produce elaborate connections between labour,
commerce, mobility, governability and desire, they also undermine the seam-
less spatio-temporal order imposed by the idea of a coherent and located
national organisation. [15] It is the degree to which nothing coheres that is so
interesting about these works and their ability to rehearse contradictions so
seamlessly merged in previous narrative tropes of life at sea. In Laura Horelli's
two-channel video work, the employees of a cruise ship — workers in a kind
of permanent carnival of entertainments — are asked to wear badges which
identify them by name and by their many countries of origin. At the same
time, they are only allowed to speak in English while on board, the one man-
ifestation cancelling out the meaning of the other. Difference is performed
and sameness is imposed within a leisure industry that pursues the produc-
tion of a floating, neutral 'nowhere' and counters the very possibility of any
curiosity or discovery as part of the experience of a voyage. The fact that
the crew also expresses no interest in any of the places they are visiting nor
do they seem to explore the ship's home base in San Juan, speaking instead
about their earning capacities and their longing to return to their homes,
further locates them in capital rather than in any geographical specificity.

All the protagonists of these different works come at the dominant tem-
porality of the world from an 'elsewhere' that is not locatable in a stable and
fixed notion of space. Although a notion of a 'solid sea' as an obstacle course
traversed at different levels and registered by the differently privileged actors

in the forms of tourists, merchants or refugees was coined by 'Multiplicity', it is at some level shared by many of these projects. This 'solidity' counters the illusion of seamlessness and transparency, reintroducing obstacles and illuminating hidden structures that negate any fantasy of freedom that may be popularly inherent in the narratives of the sea. No longer an adventurous 'in-between' in Foucault's previously quoted and somewhat romantic terms, the ships in these art practices exemplify heterotopias at the edge of the world which are nevertheless deeply implicated within capital production and circulation but at a different temporal register.

Should we be asking where she was shipping her work from, or where she was shipping it to? Would it help us to locate her question in a more empathetic manner if we understood the direction of this movement, if there was a margin and a centre to this story, to this question?

The Edge of the World

But is the edge of the world a place from which one can produce a critical gaze or is it a tragic marginality?

In his analytical writings, Achille Mbembe has placed Africa 'at the edge of the world', not as a marginal space but actually as one from which it might be possible to read new forms of emergent territorialities and un-expected forms of locality. In an exceptional reading, he argues against the overriding convention that posits African struggles of self-location at the feet of arbitrary colonial divisions of territories that cut across languages, cultures, landscapes and tribal affiliations. But equally he argues that 'the regional integration that is seemingly taking place through socio-cultural solidarities and interstate commercial networks' are not exclusively local.

If at the centre of the discussion on globalisation we place the three problems of spatiality, calculability, and temporality in their relations with representation, we find ourselves brought back to two points usually ignored in contemporary discourses. The first has to do with temporal pluralities, and, we might add, with the subjectivity that makes these temporalities possible and meaningful ... that temporalities overlap and interlace. Fitted within one another, they relay each other; sometimes they cancel each other out; and sometimes their effects are multiplied. [16]

In conclusion, Mbembe, in tandem with so many of the arts practitioners circulating around us, insists that it is the positioned viewer — the epistemological place from which we see and know — that is the major problem. 'Interpreted from what is wrongly considered the margins of the world, globalisation sanctions the entry into an order where space and time, far from being opposed to one another, tend to form a single configuration.'[17]

The co-joining of space and time seems abstract and difficult to entertain. But often it does not take the form of a grand enterprise but rather one of a level and therefore unsettling gaze.

Similarly in de Rijke and de Rooij's video *Untitled* (pp.23, 35), which focuses on a graveyard surrounded by high-rise buildings in Djakarta, we find the level and steady gaze which turns the tables on the supposed tumultuousness by which most often an 'elsewhere' is perceived and brought into vision. So often a conventional western gaze is overwhelmed by what it observes to be a chaotic or irrational logic of the elsewhere. As in Mbembe's positioning of Africa in his argument, here too it is not the choice of what is being exhibited that has changed but the formation of the viewing gaze. Equally, it is the recognition that there are necessarily multiple temporalities and that the inscription of the globe into one temporal order in which everything is synchronic is an inherited violence. For as Negri says 'Time is not only a horizon ... it is also a measure'.[18] Thus duration, horizon and the level and steady gaze which unsettles conventional perceptions of how we look elsewhere, are all the critical tools by which we can turn other locations and other modernities into 'edges' from which we can turn perception inside out.

Bio/Power — Bio/Time — New Political Spaces

I want to try and bring them all together; spatial temporalities and singularities, notions of duration and of bodies which, by performing their 'being', are actually intervening critically. I want to plot out how that which might seem diffuse is actually a productive intensity. I want to track how the level gaze of considerable duration is producing a new space rather than a new statement. I wonder if this conjunction might propose a visual culture of bio/power?

What is constantly being referred to as 'biopower' is a form of power that regulates social life from its interior rather than from its exterior ; following it, interpreting it, absorbing it and articulating it. As a term, what it might allow us to do in the present context is to make tangible conjunctions of space and time at the level of the body, of their embodiment.

The performative bodies which inhabit all of the works touched on throughout this discussion are not illustrative of ideas or actions taking place outside themselves, not characteristic of any particular cultures, nor do they illuminate particular historical moments. The fleeting ways in which they inhabit the screen — oblique, fragmented and arbitrary — ensures that they cannot become frontal actors in some historical drama but instead function as singularities in a spatial temporality.

Biopower too occupies a spatial temporality in which work is no longer reducible to a measure based upon the time of use-value, but brought into relation with the new organisation of social temporality on a bio-political baseline. In Antonio Negri's *Time For Revolution* the richness of the 'The Constitution of Time' consists simply in its being the compression and crystallization of Negri's thinking on the transformation of the time of exploitation. Time here has been conceived of as the quantitative measure of exploitation; now it can be thought of as the qualitative of the alternative and of change.[19]

The deep entanglements of cross-cultural translation and circulation and their manifestations within contemporary arts practices in which it is subjectivities that both produce and manifest bio/power, make for a much more hospitable context for the understandings of 'multitude'. 'Multitude' is what Negri and Michael Hardt contrast with juridical structure and con-stituted power. This multitude is: 'the plural multitude of productive creative subjectivities of globalisation that have learned to sail this enormous sea. They are in perpetual motion and they form constellations of singularities and events that impose continual global reconfigurations on the system.'[20]

What drives Negri and Hardt's *Empire* as a book, what drives so many of the arts practices that are taking up, consciously or not, the terms suggested here, is the tension between the ways in which the old formations (empire) constantly remake themselves, adapting and absorbing all challenges and the possible new figures and spaces for political struggle in the form of new subjectivities, new modes of 'expressive democracy'. As they state: 'New fig-ures of struggle and new subjectivities are produced in the conjuncture of events, in the universal nomadism, in the general mixture and miscegena-tion of individuals and populations and in the technological metamorphoses of the imperial biopolitical machine.'[21]

But how are these flexible multitudes, trading on their intellect rather than their capital, to create this new 'expressive democracy'? Philosophers and art-ists have of late been telling us of crowds and multitudes who are 'just there',

crowds who do not make specific demands nor carry particular banners, but instead resist an order through their sheer being.

Negri says: 'The protesters at Seattle are not unsympathetic. They don't stand for anything. They don't have a programme. But what is important is that they have found a space for a different politics — a global politics.' And Agamben claims that the fury unleashed by the authorities in Tianamen Square was directly related to the fact that the protestors had no particular demands, demands which they might have negated or condemned or negotiated with. He asserts that 'What the state cannot tolerate in any way, however, is that singularities form a community without affirming an identity'. [23] Similarly, Oliver Ressler's films patiently follow the shifting population of anti-globalisation protestors from Genoa to Salzburg to Gothenburg, charting the waters of a fluid and non-centralised emergent politics that responds to the moment rather than building political structures.

Like the performative politics of the multitude, constituting new spaces and occupying old ones with new meanings, the steady gaze of the camera evacuates spaces from their conventional signification and allows them to be temporally suspended as the newly coined 'non-subjects' of singularity.

Did she ever get an answer to her concern for whether that work might signify 'over there'? Probably not, as it was obviously never the right question. Will she be able to produce a modality between places without trying so hard? We'll see.

1 Ursula Biemann, *Geography and the Politics of Mobility*, exh. cat., Generali Foundation, Vienna 2003, p.25.

2 Eric Alliez, *Capital Times – Tales of the Conquest of Time*, Minneapolis 1996.

3 Arjun Appadurai, 'Grassroots Globalisation and the Research Imagination', in *Public Culture*, vol.12, no.1, 2000, p.5.

4 Giorgio Agamben, *The Coming Community*, Minneapolis 1993, pp.1–2.

5 Salman Rushdie, 'Outside the Whale', *Imaginary Homelands*, London 1992, p.99.

6 Jean-Luc Nancy, *Being Singular Plural*, Stanford 2000. The quotes are amalgamated from the eponymous essay of the book, pp.xii–xiii.

7 For a discussion of Milca Tomic's work in English, see Elizabeth Cowie, 'Perceiving Memory and Tales of the Other – The Video Art of Milica Tomic', *Camera Austria International*, no.72, 2000, pp.14–16.

8 Appadurai 2000, p.5.

9 Peter Hallward, *Absolutely Postcolonial*, Manchester 2002, p.5.

10 Henri Lefebvre, *The Production of Space*, Oxford 1991, p.315.

11 Homi K. Bhabha, 'Democracy De-realised', Okwui Enwezor (ed.), *Democracy Unrealised, Documenta XI, Platform 1*, 2002, p.355.

12 Appadurai 2000, p.5.

13 Michel Foucault, 'Of Other Spaces', quoted in Nicholas Mirzoeff (ed.), *The Visual Culture Reader*, London and New York 1997, p.244.

14 See Allan Sekula, *Fish Story*, exh. cat., Witte de With, Rotterdam 1995.
 For a discussion of Multiplicity's *Solid Sea 01: The Ghost Ship* and also Armin Linke's *Solid Sea 02: Odessa/ The World* see www.arminlinke.com, www.archphoto.it and www.multiplicity.it
 Laura Horelli *Untitled* was shown at Manifesta 5, San Sebastian, 2004.
 Matthew Buckingham's *Hudson River* was exhibited in *Territories: The Frontiers of Utopia and Other Facts on the Ground*, Malmö Konsthall, 2004.

15 For a discussion of the spatio-temporal order of the nation-state, see Saskia Sassen, 'Spatialities and Temporalities of the Global: Elements for Theorization', *Public Culture*, vol.12, no.1, 2000, pp.215-231.

16 Achille Mbembe, 'At the Edge of the World: Boundaries, Territoriality, and Sovereignity in Africa', *Public Culture*, vol.12, no.1, 2000, pp.259–60.

17 Ibid., p.284.

18 Antonio Negri, *Time for Revolution*, London 2003, p.21.

19 Ibid.

20 Negri and Hardt, *Empire*, Cambridge, Mass. 2000, p.22.

21 Ibid., p.67.

22 Mark Leonard, 'Antonio Negri's "Time for Revolution"', *New Statesman*, 28 May 2001.

23 Agamben 1993.

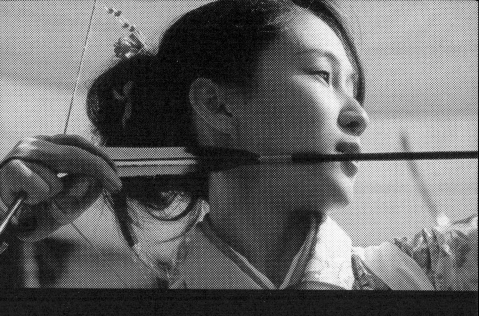

Fiona Tan *Saint Sebastian* 2001

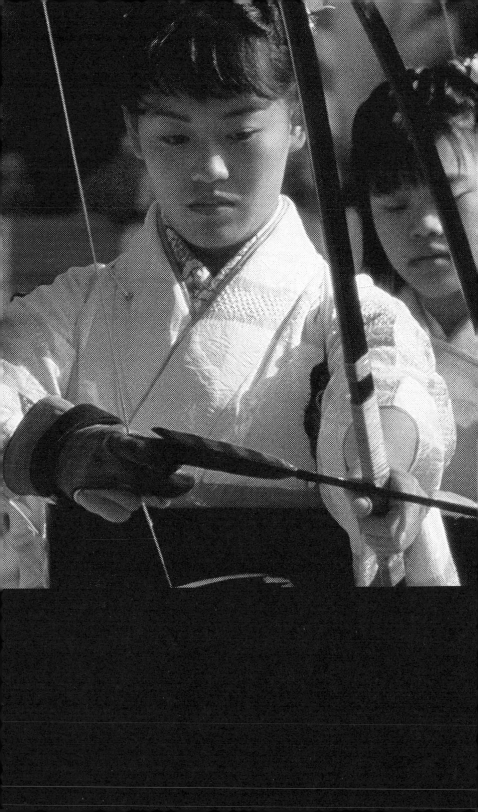

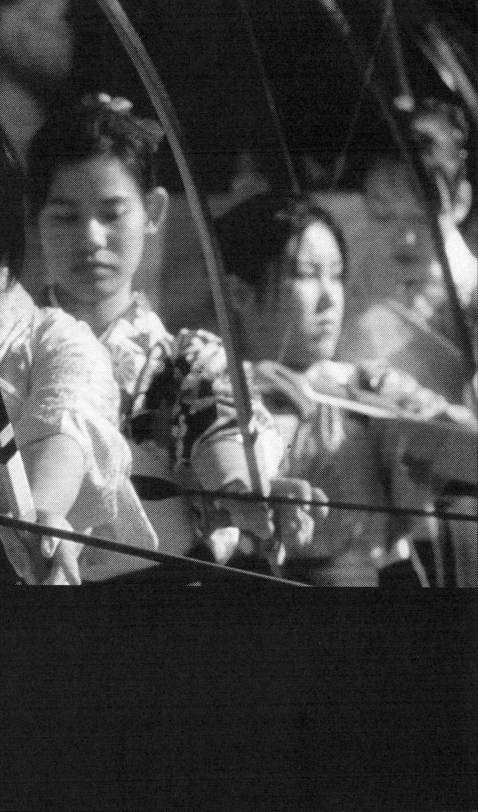

Fiona Tan *Rain* 2001

Artists' Biographies

FRANCIS ALŸS

— Born in Antwerp, Belgium, 1959
— Lives and works in Mexico

Selected exhibitions
2003 *Francis Alÿs*,
Kunsthaus, Zurich;
Reina Sofia, Madrid; Lambert
Collection, Avignon
2002 *The Modern Procession*,
project for the inaugural
exhibition at The Museum of
Modern Art, Queens, New York

Selected further reading
Catherine Lampert,
Francis Alÿs:
The Prophet and the Fly,
Madrid 2003
Francis Alÿs, exh. cat.,
Musée Picasso, Antibes and
Réunion des musées nationaux,
Paris 2001

FIKRET ATAY

— Born Batman, Turkey, 1976
— Lives and works in Batman

Selected exhibitions
2004 BüroFriedrich, Berlin
2003 Poetic Justice, 8th
International Istanbul Biennial

Selected further reading
Adrian Searle,
'Lost in translation',
Guardian, 27 March 2004
Poetic Justice, exh. cat.,
8th International Istanbul
Biennial, Istanbul 2003

YAEL BARTANA

— Born in Afula, Israel, 1970
— Lives and works in
 The Netherlands and Israel

Selected exhibitions
2004 *Wherever I am —*
Yael Bartana, Emily Jacir,
Lee Miller, Modern Art Oxford
2002 *Manifesta 4*,
European Biennial of
Contemporary Art,
Frankfurt am Main

Selected further reading
Linda Grant and Galit Eilat
(eds.), *Wherever I am —*
Yael Bartana, Emily Jacir,
Lee Miller, exh. cat.,
Modern Art Oxford, 2004
Yael Bartana, 'Self Portrait',
Tema Celeste, 2002

YANG FUDONG

— Born in Beijing, China, 1971
— Lives and works in Shanghai

Selected exhibitions
2003 *Happiness:*
A Survival Guide for Art
and Life,
Mori Art Museum
2002 *Urban Creation*,
4th Shanghai Biennale,
Shanghai Art Museum

Selected further reading
Camera — Chang Yung Ho, Wang
Jian Wei, Yang Fudong,
exh. cat., Musée d'Art Moderne de
la Ville de Paris 2003
Dreams and Conflicts: The
Dictatorship of the Viewer,
exh. cat., La Biennale
de Venezia, Venice 2003

JEROEN DE RIJKE AND WILLEM DE ROOIJ

— Jeroen de Rijke born
 Brouwershaven,
 Netherlands, 1970

— Willem de Rooij born
Beverwijk, Netherlands, 1969
— Both live and work in
Amsterdam

Selected exhibitions
2003 Kunsthalle Zürich, Zürich
2002 ICA, London

Selected further reading
Eva Meyer-Hermann (ed.),
*Jeroen de Rijke &
Willem de Rooij: Spaces and
Films 1998-2002*, exh. cat.,
Villa Arson, Nice;
Van Abbemuseum, Eindhoven 2003
*De Rijke/De Rooij:
Director's Cut*, exh. cat.,
The National Museum of
Contemporary Art, Oslo 2001

ANRI SALA

— Born in Tirana, Albania, 1974
— Lives and works in Paris

Selected exhibitions
2004 *Anri Sala,
Entre chien et loup*,
ARC/ Musée d'Art Moderne
de la ville de Paris
2003 *Anri Sala*,
Kunsthalle Wien, Vienna

Selected further reading
Anri Sala, Entre chien et loup,
exh. cat., ARC/
Musée d'Art Moderne de la ville
de Paris 2004
Anri Sala, exh. cat.,
Kunsthalle Wien, Vienna 2003

BOJAN SARCEVIC

— Born in Belgrade,
Serbia, former Yugoslavia, 1974
— Lives and works in
Paris and Berlin

Selected exhibitions
2004 3rd Berlin Biennial
for Contemporary Art, Berlin
2004 *Real World:
The Dissolving Space of
Experience*, Modern Art Oxford

Selected further reading
Daniel Kurjakovic, 'Near to
Something and Nothing and
Something', *Parkett*, no.68, 2003
Maria Lind, 'Survival Attempts:
On the work of Bojan Sarcevic',
Kunstvereinmuenchen Newsletter,
Spring 2003

WOLFGANG STAEHLE

— Born in Stuttgart,
Germany, 1950
— Lives and works in New York

Selected exhibitions
2001 *2001*, Postmasters Gallery,
New York
2000 Kunstverein Schwaebisch
Hall, Würtemberg, Germany

Selected further reading
Keith Sanborn, '2001 —
Wolfgang Staehle', essay in
Kunst Nach Ground Zero, Dumont,
Cologne, Germany 2002
(reprinted in English in
Critical Conditions, exh.
cat., Wood Street Galleries,
Pittsburgh 2003)
Wolfgang Staehle, exh. cat.,
Kunsthalle Bremen, 1990

FIONA TAN

— Born in Pekan Baru,
Indonesia, 1966
— Lives and works in Amsterdam

Selected exhibitions
2003 *Akte 1*,
De Pont Foundation, Tilburg,
Akademie der Künste, Berlin
2003; Villa Arson, Nice 2002
2001 *Matrix 144*, Wadsworth
Atheneum Museum of Art,
Hartford, Connecticut

Selected further reading
Akte 1, exh. cat.,
De Pont Foundation for
Contemporary Art, Tilburg 2003
Scenario — Fiona Tan,
Kunstverein Hamburg,
Hamburg 2000

List of Exhibited Works

FRANCIS ALŸS

Zocalo. May 20, 1999 (1999)
Single screen projection
with soundtrack

Format: Mini DV transferred to
Mpeg hard drive system
Audio, colour
Location: Zocalo, Mexico City
Edited by: No editing,
real time document
Cameraman: Rafael Ortega
Camera type: PD SONY 150
Lens: 35mm
Aspect ratio: 3:4
First presented:
Lisson Gallery, London, 2000

FIKRET ATAY

Rebels of the Dance (2002)
10 min 52 sec
Single screen video projection

Format: Mini DV transferred to
DVD; stereo, colour
Location: Batman, Turkey
Edited by: Fikret Atay
Cameraperson: Fikret Atay
Production assistants: None
Camera type: Mini DV camera
First presented: 'Undesir',
organised by Vasif Kortu,
Apex Art, New York, 2003

YAEL BARTANA

Kings of the Hill (2003)
7 min 30 sec
Single-screen video projection

Format: DVD (PAL); audio, colour
Location: Tel Aviv Coast
Edited by: Yael Bartana
Edited using: Final Cut Pro
Cameraperson: Yael Bartana
Camera type: Sony MiniDV TRV-900

Stock: 5+2
Aspect Ratio: 4:3
Sponsors/Supports: The Jerusalem
Center for Visual Arts
First presented: Annet Gelink
Gallery, Amsterdam, 2003

JEROEN DE RIJKE AND WILLEM DE ROOIJ

Untitled (2001) 10 min
35mm colour film, silent
Single-screen projection

Location: Djakarta
Cameraperson: Benito Strangio
Production assistants:
Bob Arsyad, Eno, Cobra
Camera type: Arri III with
1000ft mags and 6 x 6" mattebox
x 85 ND set
Lens: Cooke 20-100mm
Grip: Sachtler Studio 7X7,
Ronford Baker legs
Stock: 1 x 10 min Kodak 5248
Aspect ratio: Academy (3:4)
Titles: Ruud Molleman,
Studio 2M, Amsterdam
Negative cutting:
Cineco, Amsterdam
**Developed, graded and
printed at:** Cineco, Amsterdam
Sponsors/Supports: Kodak
Nederland, Singel Film
Amsterdam, Holland Equipment
Amsterdam, Yokohama Triennale
First presented: Yokohama
Triennale, Red Brick Warehouse
No. 1, September 2, 2001

YANG FUDONG

Liu Lan (2003) 14 min

Format: 35mm transferred to DVD
Black and White
Audio, colour, single-channel
Location: Su Zhou

Edited by: Yang Fudong
Cameraperson: Yang Fudong
Film includes
English subtitles
First presented: Camera, ARC,
Musee de l'Art Moderne
de la ville de Paris, 2003

ANRI SALA

Blindfold (2002) 15 min 17 sec
Double projection

Format: DVD from Digi Beta
Audio: (Dolby Surround 5.1),
colour
Score: Wilson Sukorski
Location: Vlora (left screen),
Tirana (right screen), both
Albania
Edited by: Anri Sala
Edited using:
Avid Media Composer
Cameraman: Anri Sala
Production assistant:
Carolina Gonçalves
Camera type: SONY VX-2000
Lens: Wide Angle
First presented: 25th São Paulo
Biennale, São Paulo, Brazil, 2002

BOJAN SARCEVIC

Untitled (Bangkok) (2002)
DVD (PAL) Audio, colour

Location: Bangkok
Edited by: Bojan Sarcevic
Edited using: Final Cut Pro
Cameraperson: Phillipe Stuvenot
and Thanavi Chotpradit
Camera type: Sony DV
Sponsors/Supports: Centre
Culturel Français, Bangkok,
Thailand and About Cafe, Bangkok
First presented:
About Cafe, Bangkok, 2003

WOLFGANG STAEHLE

Comburg (2001)
Live feed single-screen
projection
Silent, colour

Format: jpg
Location: Comburg Abbey near
Schwaebisch Hall, Germany
Production assistants:
Jan Gerber, Klaus Kappel
Webcam used:
Stardot Megapixel
Webcast speed: 128kbits/sec
Aspect ratio: 3/4
Sponsors/Supports:
Kulturbuero Schwaebisch Hall,
Deutsche Telekom,
Stadtwerke Schwaebisch Hall
First presented:
Postmasters NY, 2001

FIONA TAN

Rain (2001) Video installation
Mono (each monitor), colour

Location: filmed on location
in Bali, Indonesia
Edited by: Fiona Tan
Cameraperson: Fiona Tan
Sound mix: Hugo Dijkstal
Camera type: DVcam
Aspect ratio: 4:3
First presented: 2nd Berlin
Biennale, Berlin 2001

Saint Sebastian (2001)
Video installation
Stereo, colour

Location: filmed on location
in Kyoto, Japan
Edited by: Fiona Tan
Cameraperson: M. Claire Pijman
Production assistants:
Yvonne von den Steinen,
Eric Shiner
Camera type: Aaton
Stock: Fuji
Sound mix: Hugo Dijkstal
Online: Joke Treffers
Colour correction:
Hendrik Wingelaar, Valkieser
Aspect ratio: 16:9
Developed at: Cineco
Sponsors/Supports: Yokohama
Triennale, Japan
With thanks to: Shinji Kohmoto
First presented:
Yokohama Triennale, 2001

List of Lenders

Annet Gelink Gallery,
Amsterdam

BQ, Cologne

Galerie Daniel Buchholz,
Cologne

Frith Street Gallery, London

Lisson Gallery, London

Postmasters Gallery, New York

Shanghart Gallery, Shanghai

Hauser & Wirth, Zürich

Photographic Credits

Francis Alÿs images
(pp.12–13, 17):
Courtesy Lisson Gallery

Fikret Atay images
(pp.21, 28–31):
Courtesy Galerie Chantal Crousel

Yael Bartana images
(pp.32–3, 47):
Courtesy Annet Gelink Gallery,
Amsterdam

Jeroen de Rijke and
Willem de Rooij images
(pp.23, 35, 39):
Courtesy Galerie Daniel
Buchholz, Cologne

Yang Fudong images (pp.52–5):
Courtesy Shanghart Gallery

Anri Sala images: (pp.17, 63–5)
Courtesy Galerie Chantal Crousel

Bojan Sarcevic images
(pp.26, 48, 76–9):
Courtesy BQ, Cologne

Wolfgang Staehle images
(pp.81–3):
Courtesy Postmasters Gallery,
New York

Fiona Tan images
(pp.45, 101–5):
Courtesy the artist and Frith
Street Gallery, London

All works of art © the artists